D1131194

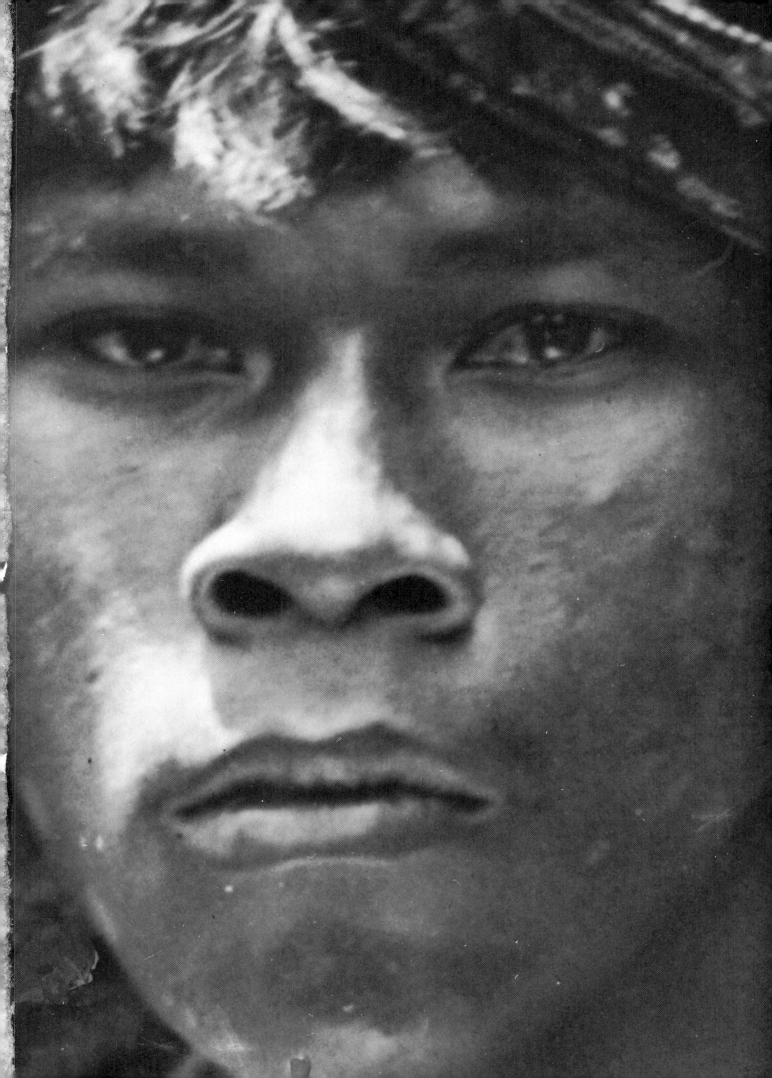

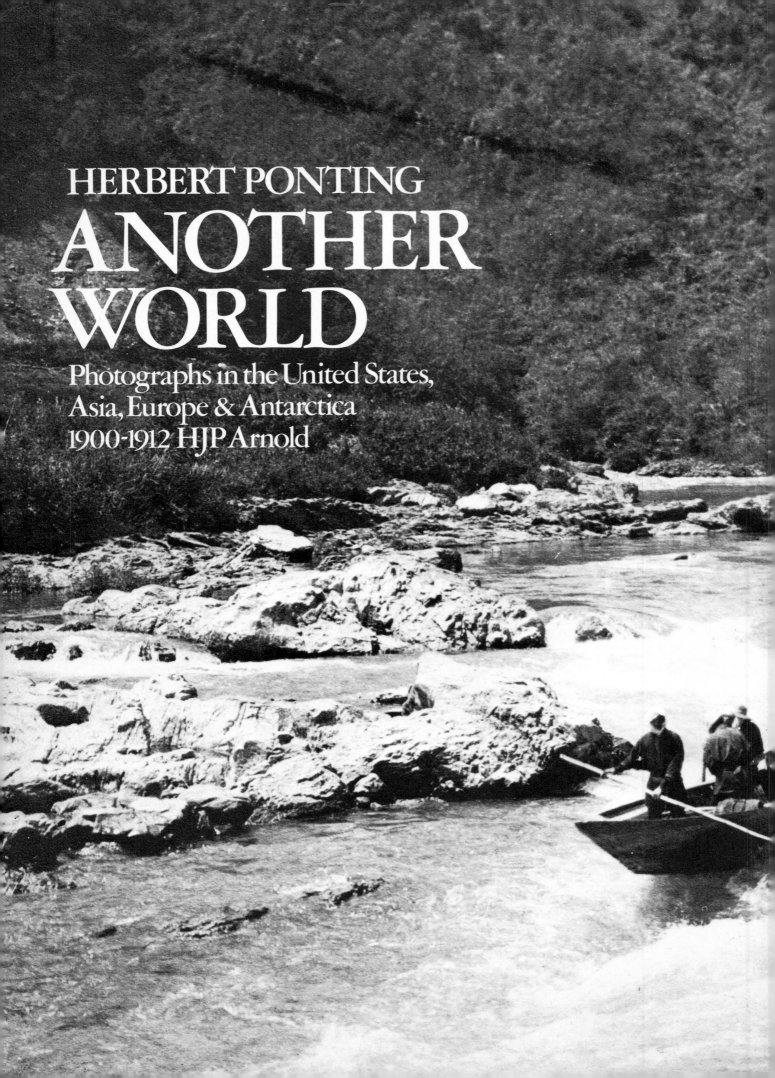

HERBERT PONTING
ANOTHER WORLD

Photographs in the United States,
Asia, Europe & Antarctica
1900-1912 HJP Arnold

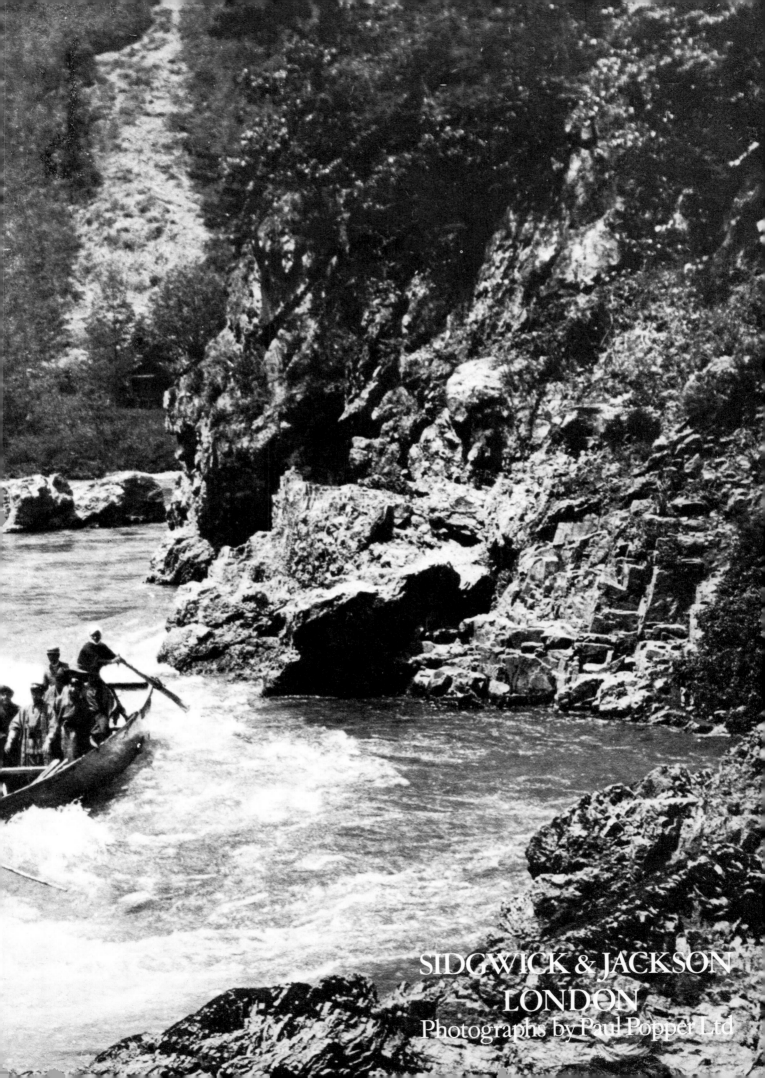

SIDGWICK & JACKSON
LONDON
Photographs by Paul Popper Ltd

To Kit and Johnny—
for their encouragement over
the years

First published in Great Britain in 1975
Text copyright © 1975 by H. J. P. Arnold
Photographs copyright © 1975
Paul Popper Ltd
Copyright © 1975 by
Sidgwick and Jackson Limited
(All photographs are copyright Paul Popper
Ltd with the exception of those on pages 3,
14–15, 33, 39, 103, 107, 114 (top). We are
grateful to Denis and Roger Houghton for
so kindly allowing us to reproduce these.
We are also grateful to Bausch & Lomb for
the reproduction of the picture on p. 5.)

For permission to reproduce from works
listed below we are grateful to: Gerald
Duckworth & Co. Ltd for *The Great White
South*, J. M. Dent & Sons Ltd for *In
Lotus-Land Japan* and S.P.R.I. at
Cambridge for the letter from Ponting to
Scott, 4 Nov. 1912

Design by Paul Watkins

ISBN 0 283 98214 4

Printed in Great Britain by
The Whitefriars Press Limited,
Tonbridge, Kent

for Sidgwick and Jackson Limited
1 Tavistock Chambers, Bloomsbury Way
London WC1A 2SG

Previous pages:

Shooting the rapids of the Katsura-Gawa.
'It is wonderful how skilfully these
Japanese boatmen dodge [the] death traps.
A fraction of a second's hesitation at such a
place, and the boat would be broadside to
the stream and dashed against some rock
and overturned . . .'

It is perhaps inevitable that the text of this book
should owe much to the biography of
Herbert Ponting which I researched for over six years
and which was published in 1969. Accordingly, I
hope that the many people who helped me with that
earlier task and who were named in the preface to the
biography will accept this more general
acknowledgement of my indebtedness to them.

In dealing more specifically with the period up to
1912, I have received further assistance from
Herbert's son A. E. (Dick) Ponting in San Francisco
and his nephews Denis and Roger Houghton of
Broughton, Lancs. The research benefited from the
advice of A. F. (Pat) Thompson of whom I asked
questions doubtless as strange as those I posed when
studying under his guidance at Wadham College,
Oxford, some years ago; Frank Baguley who is
Assistant County Librarian for Hampshire and for
whom nothing is too much trouble; and Fred Saito of
Asahi-Camera, Tokyo, who gave a valuable insight
into the history of photography in Japan and also in
China. Mrs Pat Barr also gave guidance on Japan at
the turn of the century and Mr J. R. Smith of Leeds
was kind enough to loan me period stereo-
photographs of India in his possession. The search
for additional information about Herbert Ponting in
the U.S. was aided by two of my former colleagues at
the Eastman Kodak Company—Ian Guthrie and
John Faber—while Bausch & Lomb and especially
Mrs Brigitte C. Duschen of that company did much
more than I could have expected in locating and
providing copies of Ponting's early prize-winning
pictures. My thanks to them all.

Arlene Clothier turned my illegible scrawl and
scarcely more legible typing into an immaculate
typescript with a speed which I have come to expect
but which spoils me—whilst my wife Audrey,
daughter Ann and mother-in-law Dolly Cox as ever
have given me the support and provided the
conditions which make writing as easy as it will ever
be. The ladies make it all possible.

H. J. P. ARNOLD

San Francisco Bay from Ponting's home at Sausalito. This telephotograph won him top award in its class in the Bausch & Lomb Optical Company's Quarter Century Photographic Competition which was staged shortly after Ponting took up photography seriously at the turn of the century

Contents

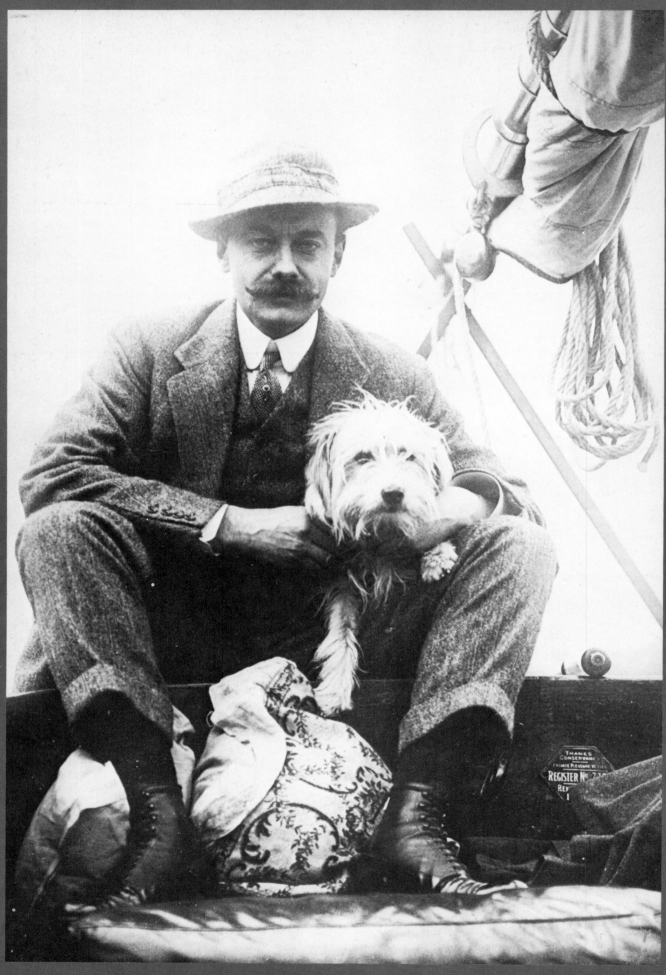

The Man

Hundreds of photographs appeared in newspapers and magazines as the Scott expedition prepared for the journey to the Antarctic. This picture of a debonair Ponting was taken prior to departure to New Zealand in November 1910

Herbert George Ponting was descended from two families of rich West Country heritage. His mother's family—the Sydenhams—had in past centuries possessed extensive property in Somerset and Devon while according to family tradition the Pontings were of Huguenot extraction.

Herbert's grandfather Henry Ponting—a Marlborough man—was born in 1822 and was probably the illegitimate son of a Miss Pontin(g) who was at the time a governess to the family of the Marquis of Ailesbury, Warden of the Savernake Forest in Wiltshire. Henry's profession on his marriage certificate was given as 'sawyer', but he was later described as an agent of the Marquis on the estate—a position of some responsibility. He married Ann Collard of Swindon in 1842 in the Parish Church of St Mary in Marlborough. Ann was the daughter of a local farmer. Judging by the education which the eldest son Francis—Herbert's father—must have received, the family was obviously not without money. The couple had eight sons and four daughters born between 1842, when Francis was born, and 1866.

It did not take Francis Ponting long to make his mark in the world of banking which was developing fast in the nineteenth century. In fact, he was so successful that he retired in his early fifties. He was obviously a most capable, if not brilliant, man in financial matters (which certainly cannot be said for any of his sons) and when he died in 1923 at the age of eighty-one the gross value of his estate amounted to over £45,000 (£40,000 net), a considerable sum by any standards.

Francis Ponting and Mary Sydenham, who married on 16 April 1868 at St Thomas's Church, Salisbury, had four sons and four daughters— Edith, Herbert, Francis Henry, Alice, Ernest, Ruth, Mildred and Sydenham—born in towns as far apart as Salisbury itself (where Herbert was born on 21 March 1870) and Carlisle as the father's banking career progressed. The family occupied at various times large houses at Stanhope Terrace, Hyde Park, in London, Watford, Ilkley, and Southport.

No record of Herbert's scholastic achievements has been traced but they were probably not distinguished. He attended Carlisle and Preston Grammar Schools and later Wellington House College, Leyland. The younger boys—most likely because their father's wealth had by then increased substantially—attended the public schools at Uppingham and Tonbridge.

The Pontings were a reasonably happy family. Life was made comfortable by the employment of several maids, a cook, a gardener and a coachman. Employment with the family was appreciated, judging by the longevity of service. Francis shared his time between the office and the family and devoted no time or effort to public or political life. Little detail has survived about Mary Ponting other than her great concern for the running of the household. She is therefore a somewhat shadowy figure but one who received much affection from her children. Life in the family was well provided for, if not physically or mentally demanding.

In 1888, at the age of eighteen, Herbert entered banking and joined a local branch in Liverpool. Four years were sufficient to convince him that he did not wish to follow in his father's footsteps and not long afterwards he set out for the west coast of the United States assisted by a generous gift from his father. The tie between parents and son continued strong and in later years, when Herbert was in England, he stayed with his mother and father. He also wrote to them whenever he could on his trips abroad.

Mary died in 1919 and when Francis was taken seriously ill in 1923, Herbert rushed to his bedside to give some blood, but in vain.

Life in America
Herbert Ponting arrived on the west coast of America during the period of the legendary 'gay nineties' of old San Francisco—although following the massive financial collapse of 1893 things were anything but gay for a while. With an unknown though doubtless considerable amount of paternal money in his pocket, Herbert purchased a fruit farm at Auburn—a town some miles to the north-east of San Francisco beyond the state capital of Sacramento. The ranch was described as 'a great English settlement' and, indeed, the towns of Auburn and nearby Newcastle contained many English people. Besides ranching, he invested with partners in gold-mining and, for some time, worked a successful pocket in the area of Forestville on the American River.

It was not long before Ponting married—and married well. His bride was a pretty and popular girl in her late twenties. Mary Biddle Elliott was the daughter of Washington Lafayette Elliott (his father was a close friend of *the* Lafayette), a general in the U.S. Army who had fought in the Civil War and had been in command of the Presidio or army H.Q. in San Francisco. The marriage took place on 5 June 1895 and a local paper recorded 'a wedding of real interest' at the First Presbyterian Church in San Francisco.

A daughter, Mildred, was born at Auburn in January 1897. But the ranch got into financial difficulties—Ponting was to display his financial ineptitude time and time again—and, towards the end of 1898, the family left for London where the second child 'Dick' was born in March 1899. After about nine months in London, the Pontings returned to a new home in Sausalito just across the Golden Gate from San Francisco. It is not clear at which stage the gold mine project collapsed but collapse it did—after a great deal of money had been invested in the attempt to find new and productive pockets.

In 1904 the family moved again, this time to a $4,500 three-storeyed home near the newly

established University of California. But, by this time, photography was prominent in Ponting's life.

According to his own account, he took up photography seriously in 1900. 'Then I had to stereograph everything I could. The beautiful stereoscopic process had a hold of me [which] . . . got stronger and stronger.'[1] If his later life is any guide, Ponting would have devoted great time, study and energy towards conquering the techniques of this form of photography—in which two simultaneous photographs are taken of a scene, from viewpoints separated by the same distance as a pair of eyes. The resulting photos are looked at through a suitable stereoscopic viewer which produces a '3-D' effect. The typical way of securing the photos was—and still is—by a camera with two taking lenses.

By chance, a professional photographer was commissioned to illustrate the area of California where Ponting was living and asked his advice on where the most promising pictures were to be taken. Ponting gave it, with an expert eye for a scene which impressed the professional. At the same time, Ponting showed some of his own negatives and the professional was even more impressed. He was advised to try his pictures in competitions and also to send a selection to one of the companies specializing in making pictures for the stereoscope, which was enjoying one of its periodic bouts of popularity. The advice was followed—with spectacular results. A 'telephotograph' of San Francisco Bay shot from his home at Sausalito was submitted in the 'Quarter Century' Photographic Competition organized by the lens manufacturers Bausch & Lomb—and won the top award in its class (Alfred Stieglitz won the grand prize). At about the same time, Ponting shot a superb picture of 'Mules at a Californian Round-up'. This was enlarged from the 5 inch by 4 inch negative as a print 6 feet long and featured in the centre of an exhibit at the World's Fair in St Louis.

The approach to the stereo company was successful, too. In a typically casual manner, Ponting later related how storage of all his stereo negatives was a problem. He submitted them to the publishers and 'I was so staggered by the prices offered that I thought this method was the best way of "scrapping" negatives I had ever known, and as often as I could I sent others along.' Within a few months, an invitation arrived to go to New York (all expenses paid) to talk business.

Ponting leaves his family

Thus began more than a decade of travel around the world in which Ponting established himself as one of the most talented photographers of the period— and one whose achievements are still highly appreciated and perhaps even envied.

In human terms, however, there was one major casualty of Ponting's successful and highly creative period in the early years of this century. Around 1905

or 1906, he returned home to Berkeley and reputedly told his wife Mary that as an artist marriage was a millstone round his neck and that he could no longer be tied down by family responsibilities. Ponting left the family and never returned. His daughter Mildred was about nine years old and his son 'Dick' seven.

Herbert was so involved with his photography that it amounted to an obsession. Whether this was the genuine or main cause of the breakdown of his marriage —an artistic renunciation of his wife—is not clear. No evidence of the personal relationship between him and Mary Ponting has survived and the children were too young to have any clear impressions. Whilst Herbert made many friends and was an excellent conversationalist and a pleasant companion, he never —neither before 1906 nor subsequently—made deep intimate friendships and very rarely took people into his confidence. Thus, once he had left the United States for good and returned to England, very few people knew that he was a married man. He was at heart a 'loner'—although, judging from his later life, there is no evidence that he ever lacked female company.

Be that as it may, Ponting not only left the young family on its own but later carried his alienation from his wife to the extent of specifically excluding her from his will: 'I declare that in no circumstances is my wife, whom I have not seen for upwards of thirty years, to receive any benefit from my estate.' Mary received some support payments from Francis Ponting until the time of his death in 1923 and (possibly) part of Herbert's pay while he was at the South Pole. When Herbert died in 1935 Mary wrote: 'The book is closed.' She survived him for only five years. There was never a divorce, only separation. Mary was prepared for divorce but Herbert refused, possibly because he may have feared the financial settlement he might have had to make.

Ponting received little sympathy from his family. His father not only helped Mary financially but also sent his youngest daughter Mildred to stay with her for some months after Ponting had left. Herbert became quite emotional at this time and told his father that he was a desperate man who was 'ready for the river'.

This emotional outlook took other forms in later years. Shortly before going to the Antarctic in 1910, he sent a message to his two children—who were then in Europe—that he wished to see them before he left. They came to London but found a note at his hotel saying that he had already left 'because he felt that if he again saw his children, it might deter his ambition to leave on this hazardous trip'. Later still, when he entered a period of acute depression and ill health in the 1930s, he lamented to a friend how 'I could be walking down Oxford Street, past my son and he not recognize me'—a throwback to an earlier day when he returned to California from one of his world trips only to be met at his front door by a son who did not recognize him and who called to Mary

Ponting that there was a man at the door 'who said he was his father'.

It is one thing to be a 'loner' when fit, active and in one's prime. It is quite different when one's strength is failing through ill health and age and one's ultimate hopes and dreams have been dashed—whatever have been the triumphs along the way. This was what ultimately befell Herbert Ponting—despite meeting innumerable challenges and achieving great success in Asia and Antarctica.

Schemes and failures

The period from 1912 when Ponting returned permanently to Europe after over a decade of travelling the world until his death in 1935 was a time of virtually continual frustration and disappointment. Indeed, he ultimately regarded the post-Antarctic period of his life as a failure and its contrast with the previous successes demands an explanation.

Two major factors contributory to this failure can be discerned—factors which stem both from the weaknesses and strengths of Ponting's character. First was his intense loyalty to Scott and his determination to devote however many years were required to establishing the memory of his 'late chief' so that it would never dim. Second was his total inadequacy as a businessman.

For some years following the conclusion of the Antarctic expedition Ponting felt despondent that his photography was not being exploited in the way he would have liked. But this and other problems slowly subsided and he devoted himself during the Great War and beyond to lecturing activities and to perfecting the movie record of the expedition. He pursued these tasks for so long and with such fierce determination yet with such poor results so far as public attendance at lectures and cinemas was concerned that far from making a reasonable profit (as was assumed by some of the other expedition members, he almost certainly lost a good deal of his personal wealth.

For example, just two years before his death he produced another version of the Antarctic movie film, *90 Degrees South*, which cost a reputed £10,000 and took three years to make but which was not a commercial success. The sole exception in this general story of failure was *The Great White South*—Ponting's written account of his time in Antarctica which was first published in October 1921 and went through a large number of reprints.

He could not see that public reaction to the Antarctic work in which he persisted was not adequate for him to cover his expenditure—so his single-mindedness ultimately became a supreme act of selflessness and one in which he never thought twice about driving himself on, even though seriously ill. Not long before he died, he wrote: 'My work for the expedition is now done. I cannot do more. I must try

to do something to retrieve the years I have devoted to it. But it is not easy, at my age. It has left me just about ruined.' This, sadly, was only too true—and his concentration on the expedition was at least partly to blame for the fact that from 1912 onwards he did little new and creative photography.

Moreover, throughout the more than twenty years of struggling—and failing—to see the Antarctic photographic and cinematographic record established in a manner which he thought befitting to the memory of Scott and his colleagues, Ponting continued to be entirely unsuccessful as a businessman. When in 1926 he told a friend that 'my only pleasure and joy is in creating things, not selling them' he should have appreciated the wisdom of his own words and acted accordingly. Ponting's father possessed and his son Dick possesses financial skills of a high order, but such skills were noticeably lacking in Herbert. Just how far this was due to a failing to appreciate the lack of potential or adequacy in the products with which he was associated; to an arrogance which assumed that what he thought was desirable should be thought so by others in the market place; or to the ineptitude of business colleagues, is difficult to say. Most probably it was a mixture of all three.

Towards the end of the Great War Ponting invested money in a mushroom farm somewhere in the south-west of England. Little is known about this

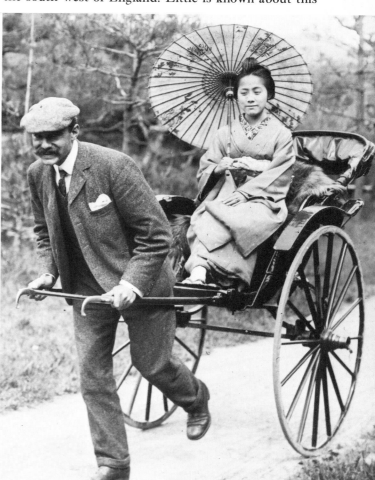

episode but that, like the fruit farm in California, it failed in a comparatively short time. He also invested in the Northern Exploration Company (largely concerned with the exploitation of Spitzbergen minerals) and apparently lost all his money.

Subsequent projects featured the *Kinatome*, a cartridge loading movie projector which was certainly ahead of its time; the *Variable Controllable Distortagraph*, a distorting lens unit which could be used on cameras or projection printers to secure distortion or caricatures and which was intended for use in the motion picture industry; and the *Ponco* unburstable inner tube for motor vehicles. (The design and construction of both the projector and the distortagraph was the work of a talented engineer called George Ford. He and his wife, Jeanne, were close to Ponting for about fifteen years up until the time he died and he seemed to draw some spiritual solace from their great and dedicated love for one another.) All of the projects were failures—though Ponting still had lingering hopes for the tube when he had to take to his bed for what was to prove to be his last illness.

Periods of ill health had increased quite markedly around the time he passed his sixtieth year in 1930. He had experienced bouts of bronchitis quite frequently for many years but what he and his doctor assumed to be bad attacks of indigestion recurred more often in the early 1930s. There is some evidence also that he had become a diabetic. Whether in company or on his own, he developed the unfortunate habit of dropping off to sleep without warning and around the end of 1934 he became so ill that he had three doctors in attendance. Eventually heart disease was diagnosed and he died in the early hours of 7 February 1935.

The funeral service took place at Golders Green crematorium on 12 February 1935 and his ashes were scattered in the Garden of Remembrance at the crematorium. The photographer's failures were reflected in the events arising from his will. Apart from a bequest to his son and daughter, he left a legacy not to exceed £2,000 net and an annuity of £500 per annum to a Miss Beatrice Gibbs—all to be paid from the proceeds of sales of the inner tube. In fact, the net value of the entire estate totalled no more than £377 1s 4d and considerable debts came to light —for example, money was owed both to the landlords at Oxford Mansions where he had his flat and to his doctor. Weeks went by in legal arguments as to whether the court should administer the estate and eventually, in an attempt to raise additional money, a sale of Ponting's pictures and photographic equipment was held in July 1935.

All in all, it was a supremely sad but absolutely predictable ending.

[1] *The Weekly Press,* 23 November 1910. Ponting was later awarded a medal by the famous Dr P. H. Emerson for 'Artistic Stereoscopic Photography'

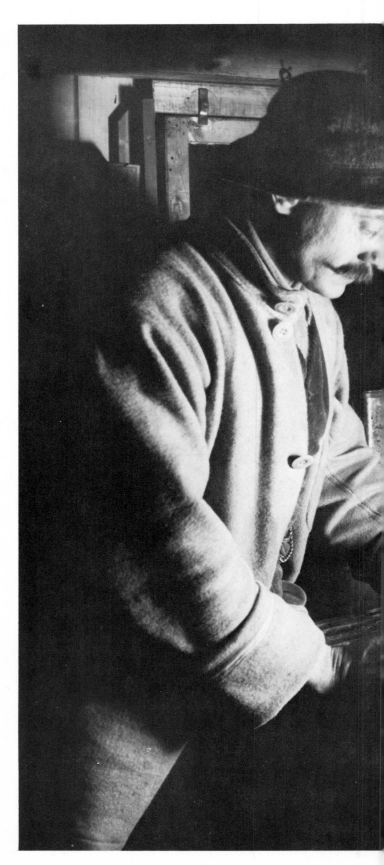

Ponting developing a negative by the light of a safelamp in his darkroom at Cape Evans in the Antarctic. He was a meticulous craftsman

His Work

In 1900 Ponting had his name to make and a world to record. What was the nature of photography at that time? The industry was introducing major new technical innovations with impressive frequency but the typical professional remained true to the time-honoured pattern of the past few decades. He used a large format camera ('howitzers' was one description of them) which took glass plates. If he was a large format man he would prefer 10 in. by 12 in. glass plates or even larger. If he was somewhat more daring, he might have been using a smaller format camera perhaps taking plates $3\frac{1}{4}$ in. by $4\frac{1}{4}$ in. The plates were much less sensitive to light than today's films, thus necessitating long exposures. The emulsion of the plates was orthochromatic (that is, not sensitive to the orange and red section of the spectrum) and development was by inspection. Enlarging was the exception and printing was often done using daylight and by contact—hence the need for large negatives. According to preference, the photographer would be making albumen prints (steadily going out of fashion at Ponting's time but still favoured by some) in which paper was coated with a thin film of egg-white before it was sensitized by a solution of silver nitrate; or possibly the very expensive plantinotype prints—using platinum—that yielded deliciously deep blacks but which were soon to be replaced by the cheaper palladium (palladiotype) prints during the First World War; or maybe carbon prints, which were Ponting's speciality.[1] The skilled man would pride himself on his ability to gauge the exposure required and might not take kindly to a suggestion that he should use the then equivalent of the modern exposure meter—the actinometer. Ponting, however, was not too proud to use it—'and vast as his experience is, he is not above using an actinometer to measure his light speed whenever he has any doubt'.[2]

But if this was the somewhat conservative world of the professional or serious photographer in the early 1900s, things were changing—to a considerable degree both stimulated by and causing the mushrooming popularity of 'snapshotting', with camera clubs and photographic magazines springing up. In 1900, for example, it has been estimated that there were four million camera owners and 256 photographic clubs in Britain.[3] The American, George Eastman, had launched his first roll film camera, and a new film on thin cellulose nitrate base (due to become the less inflammable cellulose acetate in due course) a dozen years or so before. In the early 1890s daylight-loading film rolls were introduced, and Hurter and Driffield had already published the results of their scientific investigations into emulsion characteristics which were to be of major importance to later progress. The number of genuine hand cameras—as distinct from the gimmicks of the 1880s—was increasing and the first 35 mm. still camera was only a few years away. The more convenient chlorobromide, silver bromide,

and silver chloride types of photographic papers—essentially like those used today—had already been announced and were steadily to remove most others from the market place. In 1906 the British company of Wratten and Wainwright introduced panchromatic black-and-white plates—plates with emulsion sensitive to all the visible colours of the spectrum—although they were not to become really popular for some years.

A risky world

In 1907, the Lumière brothers in France introduced the Autochrome Plate for colour photography, in which a panchromatic emulsion layer was exposed through a screen formed of a mixture of starch grains dyed in the primary colours red, blue and green—the result being viewed through the same screen. Of this system, the *British Journal of Photography* of 3 January 1908 wrote: 'There can be no doubt that the photographic event of the year, and one which will have an influence on the immediate future of photography, has been the introduction of the Lumière Autochrome Plate, and the consequent indulgence, on the part of the veriest tyro in the use of the camera in colour photography.' Other colour processes appeared in due course—among them the first 'Kodachrome' film in 1914 which was a two-colour process greatly different from today's film of the same name—but it was not until 1935 that the real breakthrough was to come. Ponting exposed some Autochrome Plates in Antarctica and seven still exist today. In later years he demonstrated little more than a passing interest in colour photography.

So it was indeed a time of fast technical progress. But arguments about the nature of photography, and in particular its relationship with the painter's art, flowed quickly and freely. Some years before Ponting took up photography, the vitriolic Dr P. H. Emerson in Britain had been attacking in scathing terms those photographers who did nothing but record artificial, staged scenes in the studio. The school of photographers who produced vast combination prints from as many as thirty negatives on the one hand and those on the other who strove to reproduce the style of the impressionist painters or of other schools of painters inevitably evoked a response from photographers of the genius of Alfred Stieglitz and others who believed that photography existed in its own right and on its own terms, and that effective pictures existed everywhere in everyday life. George Bernard Shaw—an extremely keen photographer—was active in the debates around the turn of the century. In an inimitably waspish way, he wrote: 'I greatly prefer the photographers who value themselves as being photographers, and aim at a characteristically photographic technique instead of a sham brush and pencil one . . . As to the painters and their fanciers, I snort defiance at them; their day of daubs is over.'

There is little evidence that Ponting had much time for these doctrinaire arguments. Typically, he was probably too busy exhaustively learning the techniques of his new trade, and—once he had set out on his travels—too busy working on his various commissions. Besides he was never one for intellectual debates.

If the photographic world both technically and artistically was in ferment, it was also a risky world upon which Ponting had launched himself. One man who became a photographer at the same time and who was to become a famous portraitist later wrote that there were large numbers of itinerant photographers 'little better than tramps', walking the countryside soliciting sittings from villagers. 'Photography was still in the outer suburbs of the professions and my father, a banker, was reluctant to see me embark on a career which seemed to have little but the hazardous to recommend it.'[4] When this photographer—the famous E. O. Hoppé—decided to take up portrait photography just after getting married, he was faced with a major family row and was told, 'You are mad to think of becoming a photographer . . . jeopardizing security for a wild goose chase. You ought to show a little more sense of responsibility.'[5] Fortunately, such advice was rejected by Hoppe and—if it were ever proffered to him—by Ponting as well.

Travels

In 1901—his talent already demonstrated by stereophotography commissions in the United States —Ponting went on a tour of the Far East on behalf of the magazine *Leslie's Weekly* and The Universal Photo Art Co. of Philadelphia. Not long after his return, Underwood & Underwood—another major publisher of stereo photographs—commissioned him to go to Japan, and he also took many photographs in Korea and Manchuria. Then, when the Russo-Japanese War broke out in 1904, he was accredited as a war photographer to the First Japanese Army in Manchuria, working for *Harper's Weekly* and H. C. White & Co. In the absence of diaries, it is impossible to establish the precise chronology of his travels after the Russo-Japanese War ended in 1905, but he was certainly in China and India in 1906–7, Russia in 1907 and back in Europe taking mountain photographs in Switzerland and France in 1908.

Spain and Portugal in Europe, and Java, Burma and Ceylon in Asia were other countries to which he was sent on assignment and the list of magazines and periodicals in which his photographs and also his articles appeared in Britain and America was impressive. It included *Harper's, Century, World's Work, Strand, Wide World, Metropolitan, Cosmopolitan, Sunset, Pearson's, Leslie's Weekly, Sphere, Illustrated London News* and *Graphic*. His work was featured in *L'Illustration* and other continental weeklies and he was a particularly

Mules at a Californian Round-up. This was one of the photographs that established Ponting's reputation in the U.S. in the early years of this century. It was included in what was probably his first published article and was subsequently featured in at least one major exhibition. An unerring sense of atmosphere and composition was already evident

frequent contributor to *Country Life*. Regrettably though, prior to his stay in Antarctica Ponting rarely gave details about his equipment or techniques.

The attempt to assess Ponting's work during this period is difficult on two counts. Since he was working for agencies his pictures frequently had agency and not personal credits. Thus, while today a shrewd guess can be made as to the authorship of photographs—particularly as Ponting's style developed—there are many question marks. Similarly, he contributed to so many magazines that it is almost certain that only a proportion of the total output has been traced and examined. Nonetheless, the attempt at such an assessment can certainly be made.

The earliest Ponting article of any note was published in the American journal *Navy and Army Illustrated* on 8 December 1900. It was entitled 'The Training of Army Horses'. Describing the breaking in of wild horses and mules for the German Army in China—a subject about which he obviously knew a great deal—Ponting wrote well, and

included were some excellent action shots. Masquerading under the title 'Awaiting The Kaiser's Orders' was the famous photograph later to become known as 'Mules at a Californian Round-up'.

From this time on, sometimes with both articles and photographs, but more frequently with photographs only, Ponting dealt with a vast number of subjects. In *Country Life* of 12 December 1908, he wrote eruditely—if ponderously—on the superb workmanship of the decoration on Japanese swords. (One example was 'worth as much as a crack six-cylinder motor-car'—a comment which incidentally draws attention to motoring as a life-long interest of Herbert Ponting.) In the same magazine in September 1907, he wrote an article on the Ming tombs of Peking. In *Wonders of the World*, around this period, his pictures were frequently used to illustrate articles by others—and his coverage of Burma, India, Japan and China was a particularly fruitful source of such photographs.

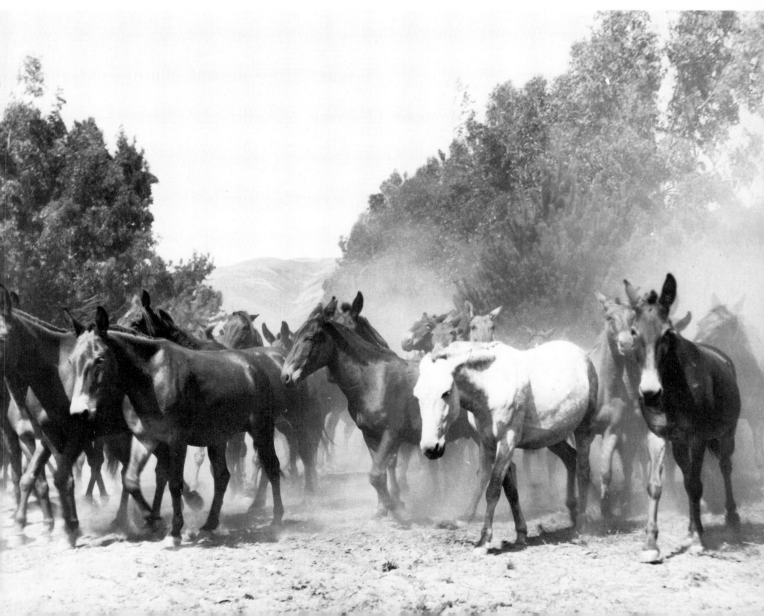

Herbert Ponting made himself an expert on Japanese swords, which had occupied such an important position in the country's history. His articles concentrated on the tsuba or hand guard, for 'on them may be found illustrated the whole of the mythology, customs, legends, folk-lore, famous scenes, characteristics and celebrated personages and events of the history of Japan'

Bottom: Panoramic view taken in about 1906 of a camel train leaving the walled city of Peking for the deserts of Mongolia—a pattern of trade which had been conducted for centuries

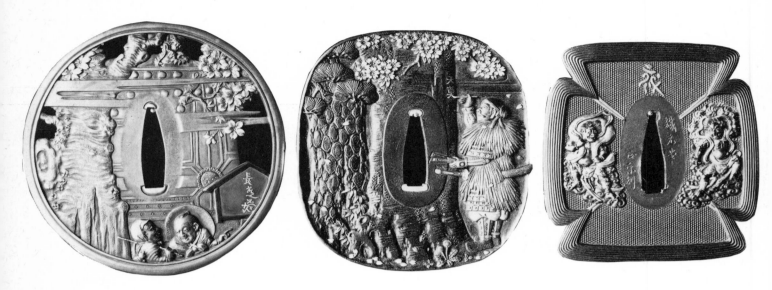

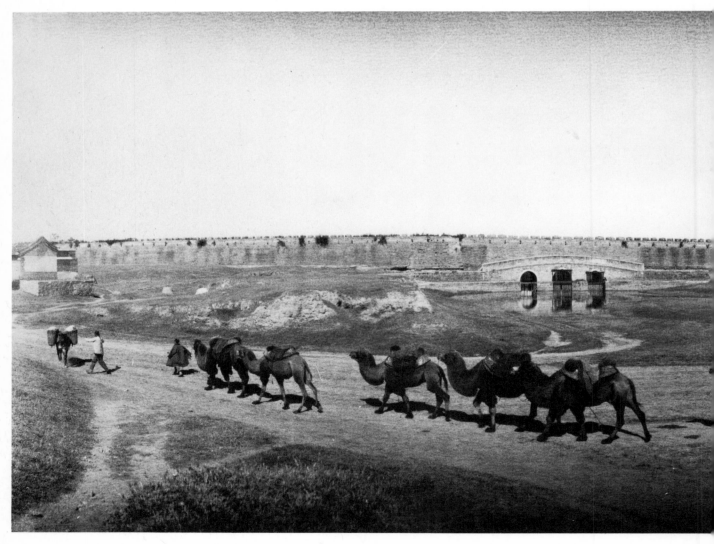

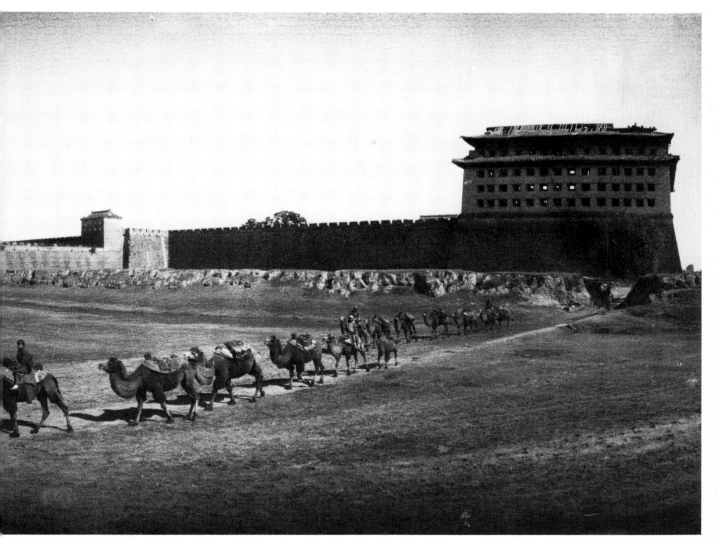

Over these early years of the century, a pattern can be discerned in Ponting's written and photographic work for the magazines. Photographically, there was much very competent *record* work for the agencies—for example panoramic views of Port Arthur and of Mukden at the time of the Russo-Japanese War—which occasionally rose to even greater heights, as in the burning of the Hindu dead on the Ganges at Benares. There was also frequent and extremely capable *pictorial* photography which rose—though even more often than in the case of the record work—to greater heights. In *Wonders of the World* a superb shot of Kangchenjunga taken from Darjeeling with a long focus lens gave an almost unbelievable impression of depth and power, while choice of viewpoint and lighting yielded photographs of the Great Wall of China which had surely never been seen before. ('I had to live for three days in a little Chinese hostel filled with Mongolian muleteers and camel drivers before the conditions were suitable for making an exposure.')[6] There had been many photographs of the tombs and monuments of the Indian emperors before, but it took Ponting to isolate the splendour of Mogul Emperor Akbar's tomb by shooting it through the fine, marble lattices of the mausoleum, leading attention powerfully to the tomb itself.

In his 'pen and picture' articles, Ponting quickly achieved a very successful formula. He researched his subject well (from Tibetan prayer-wheels to the habits of alligators) and wrote a mixture of potted history, travelogue and romance illustrated by his own photographic work. Much of this material was not truly memorable but was clearly well-suited to the requirements of the day. He rarely touched on politics, economics or social problems, and he realized (unlike many travellers past and present) that the relatively short time he spent in each country did not permit attempts at analysis in depth of complex issues.

Ponting never claimed to be an accomplished writer but when describing action he could write well. For instance, in the middle of 1907 he recorded in *Country Life* his attempts at photographing the alligators kept by a Maharajah in a lake near Calcutta. The 'muggers' were enticed from the lake by meat:

Others now began to appear on the surface and were lured ashore by similar means. I was busy photographing each specimen as he emerged from the water. By means of a pair of 8-inch lenses on a stereoscopic camera, I was able to keep at a safe distance and yet secure fair-sized portraits of them. They were easily alarmed by any sudden movement and would rush off into safety again; but the tasty scraps were irresistible . . . It was not easy, however, to get the brutes on to the high and dry ground. They preferred to remain on the safe side of the water's edge where their powerful tails could help them

manoeuvre even more rapidly than was possible on the hard surface. There was no running or hurrying about them unless alarmed. They appeared to be most sluggish brutes; the instant they were frightened at anything they would swing round and rush back to safety with the speed of which I have already spoken . . .

The Indians repeatedly warned me not to approach too near; but thinking the muggers were as much afraid of me as I of them, I became foolishly bold, and in the end had nearly cause to rue my enthusiasm. I was intently centring one on the ground glass, with my eyes well down into the hood of my reflex, when I thoughtlessly stepped back a few paces, quite forgetting that there was another ten-footer close behind me. Suddenly there was a fearful snort, the Indians yelled, there was a patter of feet, and without turning to look I took a leap and then ran. I was not a fraction of a second too soon, for the brute's jaws came together with a loud snap that fairly made my blood chill, as I realized that only my leap had saved me from being badly mangled, or, as would more probably have been the case, set upon by the lot of them and dragged into the lake.

The incident with the crocodiles. 'The Indians repeatedly warned me not to approach too near; but thinking the muggers were as much afraid of me as I of them, I became foolishly bold, and in the end had nearly cause to rue my enthusiasm'

Although obviously not intended for publication, a letter which Ponting wrote to his parents from India on 18 February 1906 reveals his narrative ability. He was writing about Benares, the sacred city of the Hindus—a subject that was later to form part of one of his lectures in the Antarctic and to greatly impress his polar colleagues:

Sunrise was accompanied by much ringing of bells and the prayers of the multitude were as the roaring of the sea, and even my boatmen as they rowed chanted now and again the long drawn out sacred syllable 'Awm'. On the terraces of the temples and palaces, monkeys jibbered at each other and hawks and vultures were waiting for the refuse from the pyres. As the great sun rose on the opposite side of the river, a sight of the most sickly horror began—the burning of the dead. This ghastly spectacle needs a Zola to paint it in prose.

The bodies, swathed in thin cloth—white for men and red for women—were brought to the water's edge and bathed in the river; some were even bathed before the breath had left their bodies; then the wood pyres were arranged and on each a corpse was placed. A relative applied the torch, sometimes a tiny boy to the pyre of his mother or a son to the pyre of his father; sometimes a father applied the fire to the body of his son; or sometimes a poor weeping half-fainting little child shrieking with terror . . . lit the fire under the still warm body of his father who had died but an hour or so ago.

The horror of it all! A whole morning from sunrise to noon, I watched the sickening spectacle fascinated with its horror and the desire to illustrate it all. Around me were old people on beds, brought to the holy river-side to die, shaking at their last gasp and close beside them the corpse burners served the hissing crackling fires.

At the end of each little pyre, the feet and head stuck out so that each body was first consumed in the middle. Then, as the fire burned low, the Domra (or corpse burners) prodded the corpses with long poles and bent and poked and beat them into the hottest parts of the fires. They broke the bodies in two, and they smashed in the skulls so that they would burn the better, and when the fire burned out before the corpse was much more than

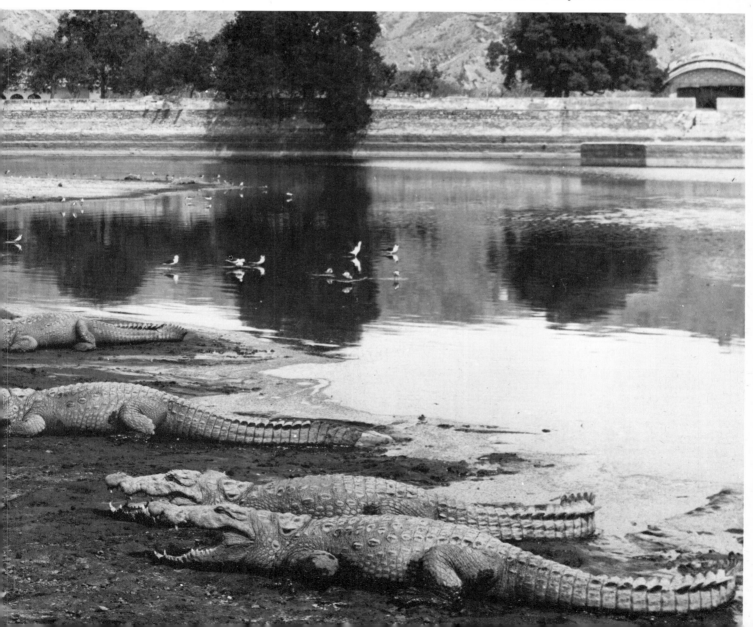

charred, as was often the case with those whose relatives could not afford sufficient fuel, they rolled the blackened trunks into the river where some sank and some floated downstream past the crowd of bathers, and some floated in amongst the boats and one I saw float to the water's edge and I turned away sickened at the sight of a lean cur tearing out its heart.

All day long, from daylight to dark, a steady stream of bodies flowed to the burning ghats and all day the smoky air was rent with the wailing of the women, the chanting of the pall bearers and the crackling of the pyres.

The poor were borne on a single pole to which the hands and feet were tied, sometimes not even a shroud covering the bodies, whilst the corpse of a rich woman was laid in a bamboo cradle decorated with fruit and was borne by many bearers and accompanied by much beating of tomtoms and cymbals. Whilst the corpse was being purified in the holy river, into which a sewer belched the city's filth not six feet away, the Domra refreshed themselves with the fruit on the catafalque and a young father came bearing the body of his baby in his arms and cast it into the sacred waters.

Ever and again a great kite swooped down from one of the palace towers and snatched a piece of flesh from the stream, and on the other side of the river vultures waited for the bodies of cattle and the corpses of those for whom no pyre could be afforded. I made a photograph of some hundreds of these foul creatures tearing a corpse to pieces and another picture showed the skeleton picked clean of every shred of flesh.

Benares, the Mecca of the Hindus—where all who can come to die—beautiful as it is in the changing lights of early day; replete as it is in picturesque charm and colour; graceful as are its minarets and magnificent as are its buildings, will always remain in my memory as a place of untold horror.

After this fearful place, how beautiful and glorious is Agra. Of Agra it seems to me I could never tire, for surely the brain of man never conceived more perfect buildings than are here. Of them all, the tomb of Itamu Daulah and the Taj Mahal are the loveliest, the latter probably the most perfect structure which ever graced the face of mother earth.

This exquisite thing—beautiful as a dream—a creation of marble inlaid with agate, cornelian, coral, jasper, turquoise, malachite, lazulite and other rare stones seems too perfect to be real. I cannot attempt to describe it, no words could do it justice and to tell of its history would be to recount a love tale which has been told again and again and again. I have brought all the skill I can command to show in my pictures something of its ethereal beauty, but how can I ever tell you of that sainted chamber in which rest the bodies of Shah Jehan and his Persian queen? How can I attempt to describe the delicate beauty of that trelised marble screen, inlaid with precious stones, which girdles the tombs? How can I speak of those pierced marble windows which temper the fierce Indian sunlight to a soft gloom? And how can I convey to you the slightest idea of the wondrous echoes which the slightest whisper awakes? A Mahomedan chanted a long note in a high tenor. Ah! the beauty of that sound. It filled the whole chamber with a clamour of music and set the air waves ringing. It lingered on the marble pavement and sprang from wall to wall. It surged

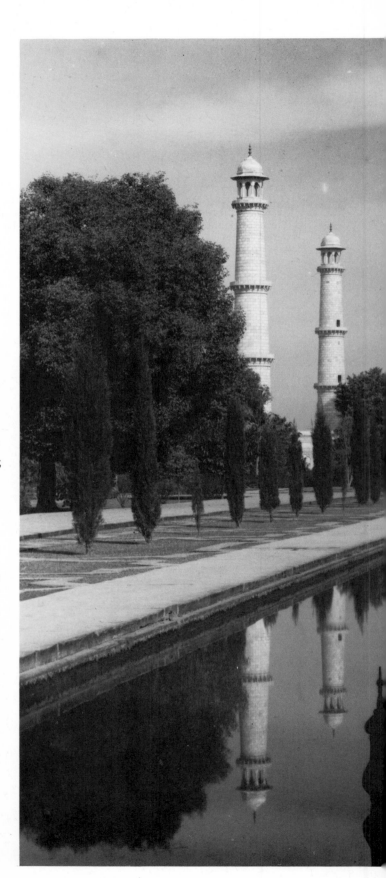

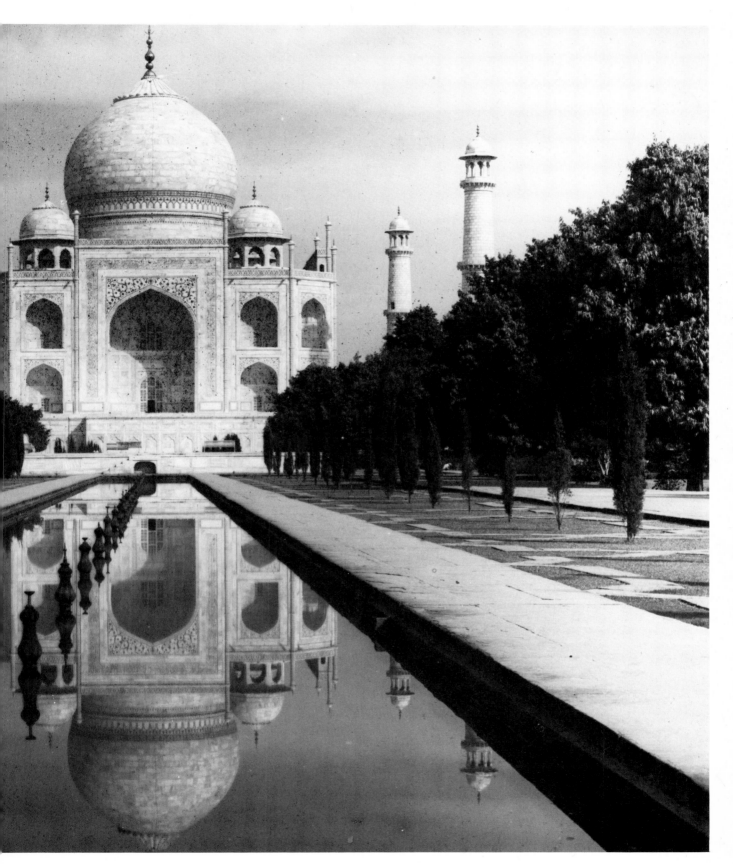

through and through the marble tracery, and ascending higher and higher in a slow quavering diminuendo, it fled, many seconds later, murmuring through the marble windows above.

To describe the beauteous Taj is beyond me. One must see it for oneself. The tomb of Itamu Daulah is so exquisitely embellished with marble tracery that I can only compare it to a delicately carved ivory jewel casket inlaid with gems.

For beauty of design this building, to me, stands second to none that I have ever seen. Not even the Taj Mahal can eclipse this beautiful lace-like thing. But the two are so different in design that they do not vie with each other. Each of its kind is supreme and each is perfect.

But even beauteous Agra has its horrors. I was wandering along the other side of the river where no one but artists and photographers and other queer people ever think of going. They were burning the body of a woman on the sand and on the banks there were many skeletons. I was making a sunset picture of the Taj Mahal across the Jumna river. A kite flew overhead bearing something large and strange-looking in its talons. It alighted a hundred yards away. Curious to know what its prey was, I ran and frightened the bird away and found the body of a baby which it had just begun to devour.

The Russo-Japanese War

During these active years of photography and writing it was however the Russo-Japanese War that undoubtedly had a major effect on Ponting's work—and accordingly the war needs setting in its context. As the nineteenth century moved towards its close, Japan attempted to expand in China and, following the bloody Sino-Japanese War of 1894/5, the southern Manchurian port of Port Arthur was ceded to it by the Chinese government. However, largely as a result of Russian pressure, Japan was later forced to give up Port Arthur and Russia herself took it over as an ice-free port in 1898. Russia also had eyes on expansion in Korea. But in 1902, Japan and Great Britain signed a treaty, the most important aspect of which was that, if Japan went to war with Russia, Great Britain would support Japan if any other European power attempted to join in on Russia's side. In fact, this agreement made a Russo-Japanese war almost inevitable—despite continued negotiations between the two countries in 1903. In February 1904, the Japanese attacked the Russian fleet in Port Arthur (before any declaration of war) and one of the fiercest struggles to that date began. Naval power played an important part but the main action on land was the drive of the Japanese armies—under the command of Marshal Oyama—out of Korea and into Manchuria. The eventual fall of Port Arthur to the Japanese army; the battle of Mukden (with about 60,000 casualties on each side); and the sea battle of Tshushima brought Japan victory and this was to have a major effect both on Russia's internal history —being a critical factor in the Revolution of 1905— and on future international developments in the Far East since a major European power had been defeated by an Asian country.

Ponting was touring the area for Underwood & Underwood before hostilities began. When the war started, he was attached to the Japanese First Army in Manchuria under General Kuroki—and was subsequently awarded the Japanese Medal and Diploma known as 'The Imperial Order of the Crown'. The lot of the western war correspondent or photographer on the Japanese side at this time was a difficult one. While the Japanese were the height of civility, they placed severe restrictions on the movements of correspondents and kept their plans very secret.[7] It was a relatively rare occurrence for correspondents and photographers to be allowed to inspect Japanese guns, magazines and store depots. Thus, while there were numerous photographs of the front from the Russian side, such photographs from the other side were far more infrequent.

There is no indication that Ponting escaped from this general Japanese policy, though there was one report of his being allowed to spend three days on the half-sunken Russian war ships in Port Arthur some months after the fall of the fortress. There was another story of the co-operative Japanese officers staging a bayonet charge up a hill so that Ponting could photograph the awesome spectacle—an objective which was somewhat spoiled by the apparent amusement of the Japanese other ranks at such a ludicrous performance, resulting in an inability to make the appropriately fierce faces.

If they did not see much of the actual war at close hand, the correspondents were extremely well received by the Japanese. Ponting had a number of formal meetings with the most senior Japanese commanders and was on good terms with them. He visited individual high officers and his knowledge of Japanese history and customs was a great asset.

The west coast of America sent a number of war correspondents and photographers to the area—one of whom was Jack London—and Ponting was always included with them as a 'Californian'. He was highly regarded by his colleagues as was shown by an article written about the Californian correspondents in the Russo-Japanese War by one of their number, Edwin Emerson—who had been one of Roosevelt's Rough Riders in Cuba during the war of 1898 and who continued to lead a very active life during the Russo-Japanese War. In the magazine *Sunset* in October 1905, Emerson referred to Ponting as 'the foremost war photographer in the Far East . . . Ponting is the man, whose exclusive photographs of Port Arthur, Mukden, Manchuria, Korea and the hostile war fleets in eastern waters were published broadcast by Underwood and Underwood at the outset of the war. Ponting was the only one who had the gumption to travel through these regions on the eve of the outbreak of hostilities, photographing everything of warlike interest in spite of frequent arrests and danger of prolonged military imprisonment. When war broke out, his unsurpassed

stereoscopic pictures of the most important places and men in the theatre of war, were in such demand that the publishers cleared many thousands of dollars, the reproductions appearing in American and European publications . . .'

After repeating praise of Ponting's work and how it rivalled the work of the best and renowned war photographers, Emerson continued: 'When I first met Ponting in the Far East, he was perched in a high ladder in the midst of a surging mob on the principal square in Tokyo taking photographs of a public reception given by Admiral Togo. Someone nearly upset the ladder. I caught it as it swayed and steadied it. Ponting merely glanced down for an instant and said "Thank you, sir". Later, when I was more formally introduced to him, he told me that he had got so used to being upset with his camera that the danger of such an accident had ceased to have the thrill of novelty.

'When I left the Far East, Ponting was just setting out again for the front in Manchuria. The last news I have of him is a quaint photograph he sent me showing him asleep in the temporary quarters of the war correspondents with Kuroki's Army in an ancient Chinese temple. He did not write who took this photograph. I am probably right, though, in presuming that he took it himself. No other war photographer, with the Japanese Army, could turn out so good a piece of work.' (And, incidentally, it was a sign of the future that in *Harper's Weekly* for 17 September 1904, photographic coverage of the Russo-Japanese War which was almost certainly conducted by Ponting should appear just a few pages away from an article titled 'The Story of The New Farthest South'—an account of the Discovery expedition to Antarctica by Captain Scott.)

'The supreme pictorial reporter'
As Ponting's name became more widely known, his work extended beyond magazine articles. In 1905, the same year as he was elected a Fellow of the Royal Geographical Society, twenty-five of his best Japanese photographs were published in Tokyo and London in *Fuji-san* and fifty more varied views subsequently appeared in a volume of *Japanese Studies* which was a beautiful example of the collotype process. Later still, a selection of *Camera Pictures of the Far East* was published. Some of the individual photographs could be purchased and prices of between two and three guineas were being quoted.

The small books of photographs were well received. *The Sphere* wrote: 'a wonderful series of photographs. Mr Ponting is not only great in his photographic technique, but he has a fine artistic instinct—a rare combination.' *Photographic News* referred quite simply to the pictures of Japan as 'masterpieces'. A knowledgeable critic and author of many works on Japanese art, Captain F. Brinkley, wrote of *Japanese Studies* in the *Japan Mail*: 'It

seems altogether a misnomer to apply the name photograph to these exquisite reflections on Nature's graces. They are quite free from the objectionable characteristics which belong to the ordinary photograph: offensive fidelity, mechanical accuracy and exclusion of all appeal to the imagination. Indeed, they seem to us to rank even higher than pictures, for the subjective element is supplied by a subtle choice of aspect, and there is a mystery of aerial perspective such as a painter's brush could not produce, or at any rate, has not yet produced. What strikes us notably in the landscapes is the cloud effect—the last thing one would be disposed to look for in a photograph. But, in truth, it is difficult to indicate any feature deserving exclusive praise.'

However, when an exhibition of Ponting's work was held by the *British Journal of Photography* at its Wellington Street offices in London in the spring of 1908, and a set of prints included later that year at the annual Royal Photographic Society Exhibition, there were some—if inadequately developed—criticisms. His R.P.S. Exhibition prints were praised for perfect technique ('a clever photographer') but an item in the *British Journal of Photography* of 18 September 1908 commented that the photographs carried 'the mind back to the photographic exhibitions of fifteen years ago . . . and one realizes . . . how far pictorial photography has advanced during the past few years . . . the work was not done chiefly from a pictorial point of view.'

Such comment had little practical effect on Ponting—though he answered the critics when he wished to—and his photographs were displayed at conversaziones of the Royal Institution, at the Canadian National Exhibition of 1909 and at the 1909 Dresden International Exhibition.

The last was the most ambitious and comprehensive exhibition of world photography held up to that date and probably has never been equalled since. One of the British selectors or 'commissioners' for Dresden was E. O. Hoppé, who invited Ponting to submit some of his Far Eastern prints. He did so and sent twelve Japanese photographs printed by the carbon process up to a size of about 60 in. by 40 in. Hoppé recorded later that he had never seen such print sizes and added: 'They were exquisite and beautiful, and the cost must have been very high. They also required enormous negatives.'

Hoppé had a very high opinion generally of Ponting's work and in the view of this man, who was afterwards to photograph everybody of importance in society from George Bernard Shaw to King George V, Ponting was the '*supreme* pictorial reporter with a superb technique'. At Dresden Ponting had his practical rewards too, for the photographs were well received and the King of Saxony bought six of them. Perhaps of greater importance, the publicity helped in advancing Ponting's claim for final selection as photographer on the Antarctic expedition.

The Buddhist Abbot of Ikegami, Japan. Ponting spent
much time studying the religious beliefs and traditions of
the countries he visited, and he treated them with
absolute respect

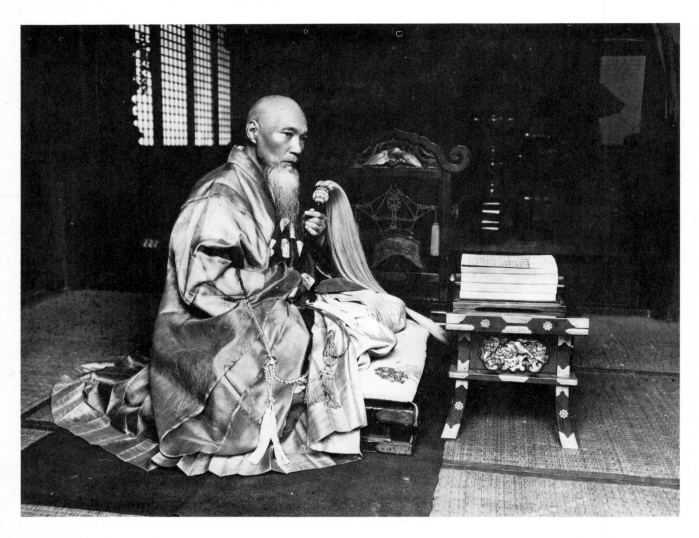

In Lotus-Land Japan

It was therefore appropriate that as he was preparing
to leave for the Antarctic in the middle of 1910
Ponting's first book *In Lotus-Land Japan* was
published by Macmillan & Co. The timing was either
very shrewdly chosen or was a most happy
coincidence. He wrote later:

June 1st, the date of the departure of the Expedition from
London, was also a memorable day in another respect for
me. It was the day on which my book, *In Lotus-Land*—
a record of my travels in Japan, on which I had been
working for the last six months—was published. Before
leaving for the docks, I eagerly opened the parcel that had
just arrived, and with no little pleasure contemplated the
dozen volumes; the handsome embossed covers of red and
gold; the large, clear print and margins wide, and the
hundred or more full page plates, each a triumph of the
printer's art, that nestled among the neat, clean pages of
the text. The publishers had sumptuously produced the
work, and they could not have chosen a more auspicious
day on which to offer it to the world.[8]

Over sixty-five years after its publication the book
is of considerable value since its 300 pages of text and
many photographs provide a comprehensive basis on
which to evaluate the work of a man whose
reputation was already very considerable.

Japan had long ceased to be a country of the
mysterious east. Indeed, in the years of the late
nineteenth and early twentieth centuries, the flow of
travel and other books about the country closely
resembled the flood of books about Russia and the
other communist countries in the period after 1945—
and the general quality appears to have been as
abysmal. Tourist trade was building up (the Hon.
Lewis Wingfield referred loftily to 'hordes of Cook's
Tour people')[9] and, in a review of *In Lotus-Land*,
the critic of the *Northern Whig* noted: 'Nowadays
hosts of globe-trotters storm through it [Japan] as
through a larger and more varied Blackpool, bidding
it stand and deliver its secrets before the challenge of
their loaded kodaks (sic).'

The activity was not only on the part of tourists
either and at one beauty spot Ponting commented:

'Artists are sketching everywhere; foreign tourists snap away yards and yards of film to help to swell the Kodak dividends, and a dozen spectacled Japanese photographers are getting pretty "bits" for postcards.'[10]

Ponting certainly could not be accused of any superficiality. Material for the book was collected over at least three visits to Japan—probably concentrated in the years 1902–5—and he eventually reached the stage where he could converse simply in Japanese. He described the book as a 'guide book for the traveller' written by somebody whose camera and notebook had been his inseparable companions in many foreign lands. Guide book it certainly was, and in the best sense of that description. He gathered together an account of Japan's early history, its customs, its religions, its art, peoples, and habits which could not be comprehensive but was an excellent primer for the intending, sophisticated visitor.

His typical thoroughness, his preparedness to to concentrate firmly on a subject which had captured his imagination, his powers of observation were revealed on every page. For example, he could seriously discuss the status of the Geisha free from western misconceptions; he took the trouble to secure translations of Japanese songs; he corrected smug western criticisms of the mispronunciation of English by the Japanese; and learnedly discussed the precise derivation of the word 'Fuji'. He had read most of the significant works about Japan by westerners (including those by Lafcadio Hearn) and pointedly wrote on one occasion: 'I have met many who have lived years in the land who could not express their simplest wants in Japanese. On the other hand the most interesting foreign residents I met were those who loved the land and liked the people; who talked the language and understood the meaning of all they saw.'[11] His observations were frequently perceptive, too—as when he wrote of the Japanese soldier: 'He does not fear death, but he does not court it, for he is far too sensible to forget that it is live men, not dead ones, who win battles.'[12]

But it was not only western misconceptions which were criticized. Thus, he refused to believe the measurements of the statue of the Daibutsu or Great Buddha at Amida as given in a book sold by the priests since a photograph 'made with a sixteen-inch lens from a distance of fifty yards, so that there is no distortion'[13] proved them incorrect!

The standpoint of the book was a clear one. Ponting was a fervent admirer of the Japanese people and—even more—of their country: 'a beautiful country', 'one of the most delightful of holiday lands'. The three aspects of Japan which most intrigued him —the countryside and particularly Mount Fuji, its women, and its craftsmen and artists—figured prominently both in his writing and photography.

While Ponting's overwhelming enthusiasm may seem overdone, he could be critical. He did not like the way in which the Japanese treated the aborigines of Japan, the Ainu; he faithfully recorded what must have been an unpleasant experience when arrested by soldiers for photographing in a restricted area; and he had no hesitation in castigating one hotel as being one of the most extortionate in the land and of complaining how prices were rising as a result of the growing tourist trade. The criticism, nevertheless, tended to be muted and the book was overwhelmingly a tribute to Japan and the Japanese—and particularly the women, with their pervading influence on Japanese life. Since he wrote the book at a time when criticism of Japan by westerners and Japanese criticisms of the west and the worst features of western life were far from infrequent, Ponting's attitude was probably a useful attempt at balancing the picture, even if some critics of the time, who were favourably inclined towards the book, found it hard to accept such statements as 'Never in history did foeman have a kinder and more generous adversary than did Russia in that struggle [The Russo-Japanese War].'[14]

In the first edition of In Lotus-Land, Ponting apologized for the 'letterpress' and commented that the text had been written around his photographs at the suggestion of friends—a point, incidentally, made by most travel writers of the period. However, many of the reviews which appeared in 1910 stated that there was no need for such modesty and that the writing stood on its own merits. And it did, although his prose was typical of the time in which he wrote and to the reader of the 1970s is often much too flowery and verbose.

But he did have much of value to say and, as indicated earlier, given the right type of subject Ponting could write a passage which almost had the strength of the natural powers he was describing— as when he recorded a descent down the Katsura-Gawa Rapids:

The captain never glanced behind him; he knew his men too well. Each was ready at his post, with pole poised in hand, and each knew the spot for which to aim. It seemed we must inevitably be dashed to pieces as the boulder raced towards us, but, just as the crash was imminent, Naojiro's pole flew out into a tiny hole in the slippery boulder's side. Simultaneously three other poles darted out as well. There was a jerk, a momentary vision of four figures putting forth their utmost strength and bending with all their strength against the rock, and the swirling waters rose level with the starboard gunwale, as for an instant our speed was checked, and the boiling current banked up against the boat. But it was only for a moment. The helmsman swung the stern round, and the great ungainly craft, grazing the boulder as it did so, took the curve and sprang over the waterfall like a fish.[15]

Ponting's attitude in the book was serious throughout and it underlines that a sense of humour was not a marked characteristic—something which

was to be revealed more clearly in the Antarctic—although he made a few brave if laboured attempts at amusing asides. Those who in later years struggled through the English of a Japanese camera instruction leaflet will doubtless appreciate, however, Ponting's story of a notice in an electric car which read: 'Parsons infected, intoxicated or lunatics will not be allowed, children without attender too.'

Ponting was the complete globe-trotter. He could compare the track up a hill called Kagozaka with the Mount Tamalpais Railway in California or the line up the Himalayan foothills to Darjeeling. A mountain called Myojin-yama was compared with the Gornergrat in Switzerland, Le Brevant in France or Yosemite Point in California. The great bell of the Chio-in temple reminded him of others in Russia, Burma, Peking and Korea. These and other similar references in the book were clearly not intended to impress the reader with the extent of Ponting's travels but to place the subjects described meaningfully in the context of the world's natural phenomena or of man's culture. For example:

There are four of the works of man in the East that have left indelible impressions in my memory. They are the Shwé Dagon Pagoda at Rangoon, the Taj Mahal at Agra, the Great Wall of China, and the Kamakura Daibutsu.

About the Shwé Dagon—that tapering golden finger piercing the turquoise sky by the great Irrawaddy—there is a delicious dream-like atmosphere, as one listens to its thousands of tiny gongs, all tinkling in the heavily incensed air, and sees the fairest maids of Burma match their palms in prayer at its base each evening as the sun goes down. The Taj Mahal—that love-tale in marble and rare stones—pearl of India's buildings and mirror of a great king's heart—seems also like some palace of a world of dreams. Before the Great Wall one has an indescribable feeling of awe, as the eye follows its interminable meanderings across the barren hills and sunbaked wastes of China. But the Daibutsu—that wondrous embodiment of Buddhist ideals—seems to be vestured in the very cloak of peace, so subtly has the hand of man clothed it with serenity and spiritual calm.[16]

At a different level, Herbert Ponting could take most events in his stride. The mixed bathing in Japan—'the nude is seen but not noticed . . . '—scarcely caused one Ponting eyelid to flutter, even when he was participating! And like the professional globe-trotter he was, he had an utter contempt for the antics of amateur tourists—whether it was the destruction of property to secure mementoes or trampling over a Buddha statue for photographs to be taken.

On the various ascents of Japanese mountains, he revealed his climbing background though on one occasion he appeared to be somewhat irresponsible in attempting an untried way down Mount Fuji with inadequate preparation and on another in letting his delight at the view to be seen at the top of Fuji's crater get the better of his caution and lead to an incident where, engulfed in cloud, he could have died of exposure.

Ponting was not only a brilliant photographer of mountains—he wrote well about them, too:

Those who have spent holidays in the Alps, and have slowly fought their way up some icy peak, will know the steady mechanical pace set from the outset by the Swiss guides. Probably, before they knew better they wanted, as I did, to go faster, much faster, but were kept in check by the men to whom this is no pastime but the business of their lives. It is the only way to scale a mountain—to adopt a slow and steady pace and keep it up like a machine; and it is marvellous what the slow, steady gait will accomplish. Hour after hour you plod on, slowly and surely, yet, almost imperceptible as your progress seems, eminence after eminence is gradually gained in the silence of deadly earnest, broken only by the crunching of your boots and the squeaking of your ice-axe as, using it for a staff at each step, you plunge its point into the snow. The light of the moon that helped you on your midnight start now pales, the sky becomes grey, and the grey gives way to pink and amber as the sun rises; but still you plod on, stepping in the footprints of the guide in front. At last, almost before you realize it, the struggle is over. Your pulse beats quick and strong and your whole body glows —not only from the effects of the exertion but with the joy of knowing you have achieved your ambition. You have gained, for the time being, the height of your desire; and, from the topmost pinnacle of that icy finger which beckoned to you from the skies, you can revel in joy undreamed of by those who have never sought the solitude of the mountains and the joy which they can bestow on those who love them[17]

While *In Lotus-Land Japan* contains little photographic detail, what Ponting did write emphasized his thoroughness and patience in securing the photographs he wanted, no matter how long he had to wait. He was prepared to spend a week on the summit of Fuji to get satisfactory views of the surrounding countryside and on another occasion, he wrote:

Many happy days I spent with my camera in this lovely spot; but not until three years later, and after I had tramped the fourteen miles to Nakano-kura-toge and back more than a dozen times, and waited patiently for many an hour, was I able to take the photograph of 'Fuji and the Kaia Grass'. Sometimes, when the mountain was clear, there would be too much wind, and the grass was blown about so violently as to render the making of the desired picture impossible. And sometimes the grass would be still, but Fuji obscured by clouds. At last, however, the long awaited moment really came. The mountain was clear; for a few brief seconds the grass was still, and during them I secured the coveted picture—which depicts the mountain in early winter.[18]

(His camera was probably stopped down to as much as f/64 to get both the grass and the mountain sharp and this would have demanded a long exposure. A filter was also used.)

Ponting (right) and a companion looking into the crater of the Asama-yama volcano, Japan. It became active and Ponting had to race after his porters to retrieve a hand camera before he could 'get a picture at the lip of a volcano in a state of violent activity'

In a further passage, Ponting described how four porters were needed to carry his photographic kit and luggage 'and there was but a small basket of the latter', whilst with the photographer's eye he commented a little later that: 'The site of every cottage among these hills and dales seemed to have been chosen only after mature and careful consideration with a view to securing the best and most artistic effect. Each little humble dwelling stood just where it ought; were it moved either to left or right the picture would be marred.'[19]

Securing another picture—which necessitated the blocking of a road, whilst 'a good deal of time passed' —led to a brush with the police and a fine of no less than 6s! On yet another occasion, he risked his life to get the shot he wanted—something that was to occur in Antarctica. He was in the crater area of the 8,280 feet volcano Asama-yama when it became particularly active:

Great black whorls of smoke belched from the crater, being emitted with such force and volume that they were pushed far back into the teeth of the wind; and several times we had to retreat quickly as they bellied out toward us. They rose to the heavens in writhing convolutions, and from the centre of the mass billows of snow white steam puffed out, and bulged beyond the smoke. And as white and black rose higher and higher in turn, they mingled with each other, and soared up to the skies in a gradually diffusing pillar of grey, which was tilted northwards by the wind and borne off rapidly into the clouds above.

Here was a wonderful chance to secure a unique photograph, but on looking round for the coolies, I saw them madly rushing down the mountainside with my cameras as fast as legs could carry them. Realizing that if I did not stop them I should miss the chance of a lifetime to get a picture at the lip of a volcano in a state of violent activity, I ran after them, calling to them to stop. The guide shouted back that we should all be killed if we did, and they continued their rush down the mountainside faster than ever. They raced over the smooth ash and leapt over stones like deer, regardless of the damage such a pace might do to my apparatus, which was packed to suit a more sober gait. Failing to check them with my shouts, I ran after them, and, being unencumbered, soon overhauled the man with my hand camera. Quickly unlashing the camera from his pack, I returned with another and older coolie—who had stopped at my bidding—to the crater's lip, and there hastily I took some snapshots, and then rewarded the old fellow with a substantial gratuity, much to his satisfaction.[20]

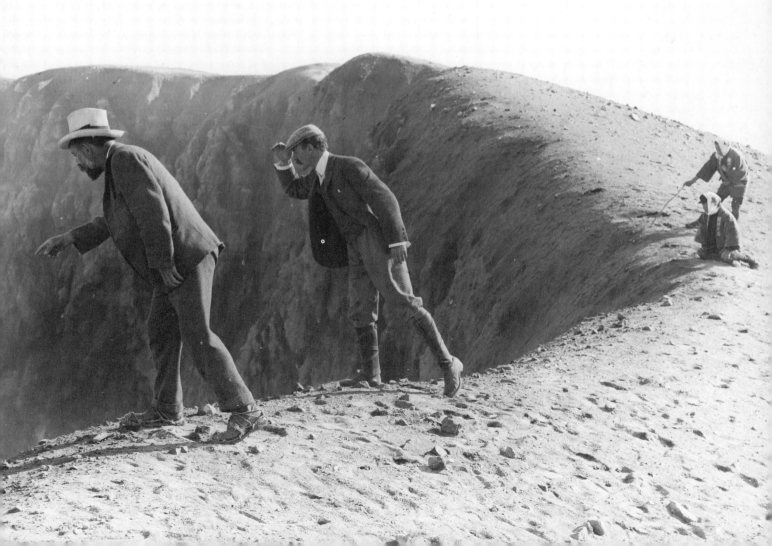

A large number of Ponting's photographs of Asian countries had already appeared in a variety of publications and collections of his Japanese pictures had also been produced. Nonetheless, *In Lotus-Land Japan* was deservedly reviewed widely—from the *London and China Telegraph* to the *Scotsman*; from the *Daily Telegraph* to *The Ladies' Field*; from *Photography* to the *Wigan Observer* and *The Hardware Trade Journal*! In all, Ponting's comment in the introduction to the new and revised edition of the book in 1922 was fair: 'the book was received with unanimous and generous approval by the press'. The *Standard* recorded that 'As an artist of the camera he is unrivalled'; the *Yorkshire Post* stated 'among the best results by camera we have ever seen'; while *Photography* noted that the book contained 'over a hundred of the most admirable photographs' and praised his photographic technique which yielded the kind of photography which did not leave the viewer 'as ignorant of the appearance of the things they represent as we were before we saw the photographs' —a reference to the popular printing manipulations of the time. The *Daily Mirror* and the *Civil Service Gazette*—surely strange companions—were the only journals which made a feature of Ponting's references to mixed bathing in Japan!

The standard of photography in the book, examined after the passing of decades, was high if somewhat uneven. Technically, the quality was as impeccable as it ever had been or would be. The tonal range of the prints was superb and indicated excellently exposed and processed negatives, whilst some of the shots which were taken indoors showed that Ponting was a complete master of available light photography. He was extremely proud of his photographic essays of Mount Fuji and he wrote in the introduction to the 1922 edition of *In Lotus-Land Japan*: 'Some of the writer's original studies, and more particularly those of Mount Fuji, have been copied by Japanese photographers, and by artists and craftsmen working in various metals and textiles. Lest, therefore, there be any who question the origin of these photographs, an extract is appended from a review which appeared in one of the newspapers of Japan when the author's *Fuji-san* was first published.'[21]

The review from the *Japanese Times* to which Ponting referred was by an expert—Professor Basil Hall Chamberlain—and read: 'It would scarcely be an exaggeration to say that Mr Ponting has discovered a new mountain; for no one has ever seen a great quiescent volcano depicted from so many points before, except, indeed, from the pencil of Hokusai. But then, this great painter gave representations that were half true, half fanciful, whereas the pictures before us are pure and unadulterated truth.'

He had reason to be proud and the numerous photographs of Mount Fuji were the equal of the studies that were to follow of the Alps and of Mount Erebus and the Lister Range in Antarctica. Ponting sought different views and varying conditions[22] with a doggedness which deserved the results he frequently secured—and landscape photography was undoubtedly the greatest strength of *In Lotus-Land* as it was to be in Antarctica. More especially, he had a feeling for the moods of mountains which has rarely if ever been equalled since—Japan, Antarctica, the Alps, they were all recorded with an unswerving skill.

Ponting never spoke of himself as a portraitist, but he not infrequently took photographs of men— sometimes in the style of a portrait and at other times showing them at work—which were of great power and which were fine character studies. There were a number of these in the Japanese book, in particular those depicting the craftsmen of Kyoto— men for whom Ponting had tremendous respect. He hated imitation in any shape or form and regarded originality as being one of the greatest characteristics of the best Japanese artists and craftsmen. In the famous Kinkosan workshop, however, he recorded how he found his Fuji photographs being copied on to tea plates: 'I felt that the only attitude to adopt in the circumstances was one of "Shikata ga nai" (it can't be helped), and to comfort myself with the solace that imitation is the sincerest form of flattery.'[23]

There was one less successful feature of *In Lotus-Land*. Although it may be surprising—given Ponting's attitude to Japanese womanhood (or because of it?)— a considerable number of the photographs of Japanese girls and women, whether as main subjects or as foreground interest, were contrived, uninspired, and absolutely predictable. The technical skill was still there and the prints were needle sharp, with a full range of tones and usually divided into the classical proportions. The element that was absent was some sign of imagination and of life. Ponting's later attempts at portraits of women were also unhappy and the conclusion must be that he was always a good and frequently superb photographer of nature and of men, but less so of women. Photographs of Japanese women in traditional costume and in garden settings were common postcard subjects of the time and it may be that Ponting could not sufficiently remove these stereotyped images from his mind. Pictures of women and girls taken by available light indoors, however, were much more successful.

In fairness to Ponting, it might be that these unfavourable impressions stem from a viewer's lack of knowledge of Japanese customs and attitudes. Defending his concentration on lotus gardens, for example, he wrote in the *British Journal of Photography* of 23 October 1908: 'Many of my photographs have a deeper meaning than the untravelled will perceive.' In addition, it must be stressed that few of the reviewers found any fault in this direction save for the *Illustrated London News*

which—while bestowing general praise on the book—commented that the eight hand-coloured shots in it (most of them women) were 'conventional and of little worth'. Be that as it may, the book sold well and went through two editions before being revised and published again in 1922.

Ponting's Japanese photography was later to have a use which he could not have foreseen when he was engaged upon it. In his diary for 29 May 1911 in Antarctica Captain Scott wrote:

Tonight Ponting gave us a charming lecture on Japan with wonderful illustrations of his own. He is happiest in his descriptions of the artistic side of people with which he is in fullest sympathy. So he took us to see the flower pageants. The joyful festivals of the cherry-blossom, the wistaria, the iris and chrysanthemum . . . and the paths about the lotus gardens where mankind meditated in solemn mood. We had pictures, too, of Nikko and its beauties, of Temples and great Buddhas. Then, in more touristy strain, of volcanoes and their craters, waterfalls and river gorges, tiny tree-clad islets, that feature of Japan—baths and their bathers, Ainos and so on. His descriptions were well given and we all of us thoroughly enjoyed our evening.[24]

The last sentence of a review of *In Lotus-Land* which appeared in the *Geographical Journal* in September 1910 read: 'His photography is superb. . . . The British Antarctic Expedition should be well served by the camera in Mr Ponting's hands.' It was.

Antarctica

Once selected by Captain Scott as photographer of the Antarctic expedition—from over 100 applicants, so the story went—Ponting threw himself into the job with typical energy and thoroughness. He was given a virtual *carte blanche* to ensure that the photographic record would be complete and his preparations for the still photography were meticulous. But he regarded the movie coverage as being of special importance. Since he was inexperienced in this form of photography he turned to one of the specialists of the day, Arthur S. Newman. Newman later recalled:

When he arranged to go with the Scott Expedition to the South Pole as official photographer, he came to me and said that as the kinematograph was well established, he wished to take a kine camera as part of his equipment, but as he was quite ingorant of the particular methods used, he desired me to tell him all I was able, and together we took many films and developed them, had them printed or printed them ourselves, and studied the projected results. He was exceedingly severe in his criticism of the results.
His great objection to the pictures then being shown at the picture theatres, was the fact that the movements of people and animals were not natural, and I made several comparative exposures to prove why the general trend of animated subjects was jerky and stilted.
When the results satisfied him in this particular, he

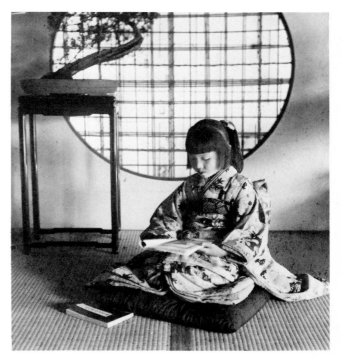

took up kinematography with enthusiasm, and from that time his still camera took a second place in his ideas . . .
He was a great experimenter and would always try out any idea before condemning it. I have made many appliances for him, some of which I knew could be of small value. When I tried to dissuade him from proceeding to spend money on what I considered a useless idea, he would say 'Well! You may be right, but I still want to try it out'.[25]

Ponting suffered severely from sea-sickness during the voyage of the *Terra Nova* from New Zealand to the Antarctic but he refused to allow this to interfere with photography. Moreover, although hurt during a storm he was far more worried about the flooding of his darkroom—so much so that when everybody else was fighting desperately to save the ship he devoted himself exclusively to safeguarding the photographic apparatus and materials.
Once ice was encountered, he gave his new colleagues a foretaste of his dedication. He was determined to get movie footage of the *Terra Nova* crashing through the icefloes. Some planks were rigged up, 'extending ten feet from the starboard side of the fo'c'sle, to the end of which I fixed the kinematograph with its tilting-table. Spreadeagling myself on the end of these planks, I had a field of view clear under the overhanging prow. As the ship bumped into the floes, I hung on as best I could, and with one arm clung tightly to my precious camera lest it should break loose and fall into the sea, whilst with the other hand I turned the handle.
Fortunately no mishap occurred; and the result—showing the iron-shod stem of the ship splitting and rending the broken ice into the foaming sea—proved

to be one of the most thrilling of all the moving-picture records of the Expedition.'[26]

In January 1911 the building of the expedition's winter hut at Cape Evans began and Scott gave Ponting permission to devote himself to photography while the weather was fine. This decision was absolutely correct but other members of the party felt some resentment at Ponting's being excused the hard work and tedium of unloading supplies from the ship and establishing the winter quarters on the ice. This feeling persisted subsequently and, while there is no evidence of any strong antagonism, Ponting never seems to have been regarded as a 'team-man' or fully committed explorer in the same way as was Frank Hurley, the talented Australian photographer who participated in six Antarctic expeditions from 1911 to 1917.

In fact, Scott invited Ponting to lead one of the geological parties but he stepped down in favour of a trained geologist—a gesture which Scott appreciated but which had the effect of accentuating Ponting's lonely role. There is little doubt, however, that the photographer welcomed the outcome: 'The western journey would not have enabled me to take my own time over my work, and photography in these regions is too important and difficult to be done in haste.'[27]

Ponting was in a fever of activity in the weeks and months before the sun set for the winter on

22 April 1911. His darkroom had to be prepared in the hut and the maximum photographic advantage taken of the hours of daylight—frequently when his companions were asleep. Scott noted in his Journal: 'Ponting is the most delighted of men; he declares this is the most beautiful spot he has ever seen and spends all day and most of the night in what he calls "gathering it in".' And again: ' . . . [he] is enraptured and uses expressions which in anyone else and alluding to any other subject might be deemed extravagant!'

It was, indeed, during this period that some of Ponting's greatest Antarctic photographs were taken —including 'A Grotto in an Iceberg' and 'The Death of an Iceberg'.

The photographs were not obtained without personal danger. Ponting's escape when killer whales attempted to break the ice on which he and two expedition dogs were standing subsequently received much publicity but it was by no means the only such incident. Other situations were possibly more frightening because Ponting was entirely on his own:

As I neared the bergs, I was perspiring freely from the effort of dragging my sledge; and the yellow goggles, which I wore as protection against snow blindness, became clouded over, so that I could not see. I was just about to stop to wipe them, when I felt the ice sinking under me. I could not see a yard ahead because of my

Antarctic darkroom. 'It was eight feet long, six feet wide and eight feet high . . . Every available inch of storage space was utilized, even the ceiling . . . This room was kept spotlessly clean and neat for . . . in matters photographic untidiness is abhorrent to me'

clouded goggles, but I felt the water wet my feet, and I heard a soft hissing sound as the ice gave way around me. I realized instantly that if the heavy sledge, to which I was harnessed, broke through, it would sink like a stone, dragging me down with it. For a moment the impulse was to save myself, by slipping out of the harness, at the expense of all my apparatus. But I went to the frozen South to illustrate its wonders, and without my cameras I was helpless. At all costs, therefore, my precious kit should be saved. I would save it, or go down with it. We would survive or sink together.

A flood of thought rushed through my brain in those fateful moments. I seemed to visualize the two hundred fathoms of water below me, infested with those devils, and wondered how long it would take the sledge to drag me to the bottom. Would I drown, or would an Orca (killer-whale) snap me up before I got there?

Though the ice sank under my feet, it did not break; but each step I expected to be my last. The sledge, dragging through the slush, became like lead; and as the water rose above my boots, I was unable to pull it further. Just then, with perspiration dripping from every pore, I felt my feet touch firm ice. With one supreme, final effort, which sapped the last ounce of strength that was left, I got on to it, and managed to drag the sledge on to it too; then I collapsed—and if ever I breathed a fervent prayer of thanks to Heaven, it was that night. I was so completely exhausted that it was quite a long time before my trembling muscles ceased to quake.

But at that point—like the dedicated professional he was—Ponting took the photograph that he had gone to the spot to secure.

During the Antarctic winter Ponting continued to take photographs outside by flash whenever possible, caught up with a heavy backlog of processing and joined in the programme of talks and lectures with great success. But it was a difficult period for him and Scott became worried: 'Ponting is not very fit . . . his nervous temperament is of the quality, to take this wintering experience badly . . .'. Ponting himself admitted that he found the absence of sun—which was essential for his work—and the absence of any change of scene 'more irksome to me than to any of my comrades'. But although he was highly strung, introspective and depressed at times he nonetheless had the determination and stamina to get safely through the winter. And not only that: he withstood bantering and teasing as well as anybody and showed repeatedly the deep regard he had for his colleagues and their work—whether it was Scott himself and Dr Wilson or some of the less well known members of the party. With the coming of the sun spirits rose and Ponting began teaching Scott, Debenham, Bowers, Gran and Wright how to take photographs with an enthusiasm and skill which could not have been bettered.

At the end of October 1911, Captain Scott and the other members of the polar party set out on the journey from which they were not to return. Ponting accompanied them for a few miles to secure movie footage of the departure—and then threw himself into

an intense programme of photography at Cape Evans and Cape Royds which lasted until he left for New Zealand in the *Terra Nova* in March 1912. While there were many facets to the work—including superb 'tele-photographs' of the Western Mountains across the McMurdo Sound—his greatest achievement during this period was undoubtedly the still and movie photography of Antarctic animal life— the seals, penguins and skua gulls in particular. Even more important, the photographic record was extensive enough to corroborate or correct the opinions of the experts on various aspects of animal behaviour. In so doing Ponting demonstrated the seemingly limitless resources of patience and the ability to overcome long, tiring periods of failure that is the characteristic of all good nature photographers.

Even here there was danger to limb if not to life:

When I was recording the final phase of one of the [skua] chicks kicking off the last bits of shell, the parents were swooping wildly around me, screaming with rage and fear as they heard the 'peeping' of the struggling little ones. Just as I had finished the work and rose from my kneeling position, I received two blows in rapid succession, one on the back of the head and the other in the right eye. As I held both my arms close to my face for protection, two more blows were delivered, one just at the back of the ear, which almost bowled me over. Suffering acutely, I lay on the ground for an hour or more, my eye streaming with water, and I could see nothing with it. I really thought the eye was done for— as it probably would have been, had I not been wearing a heavy tweed hat with a wide brim. The joint of the gull's wing struck the brim of the hat, and beat it down against the eye; but for that wide brim I should certainly have received the blow full in the eye, and probably have lost it.

The infuriated birds made no further attempt to molest me as I lay on the ground, nor did they attack the camera either—seemingly comprehending that it was an inanimate thing that could do them no injury. Had they not attacked me, no harm would have resulted to the chick, for I had just finished the picture; but by the time I had recovered sufficiently to take the camera away, the chick was frozen stiff, the parents had forsaken it and were nowhere to be seen. My eye was weak for many days afterwards; but fortunately it had suffered no permanent damage, and it ultimately got all right again.[28]

Herbert Ponting wrote at length in *The Great White South* on the practice of photography in Antarctica—and it was a story of difficulty from beginning to end:

When working the camera, I would remove both pairs of mitts until my hands began to chill in the woollen gloves; then bury them again in the warm fur, and beat them together until they glowed again. But my fingers often became so numbed that I had to nurse them back to life by thrusting my hands inside my clothing, in contact with the warm flesh . . . I found that it was advisable always to leave cameras in their cases *outside* the Hut. There was sometimes a difference of more than

29

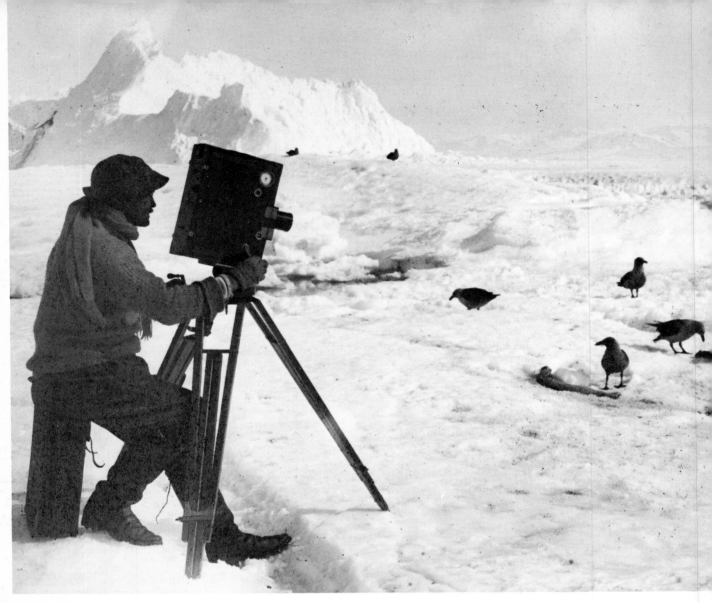

one hundred degrees between the exterior and interior temperature. To bring cameras inside was to subject them to such condensation that they became dripping wet as they came into the warm air. If for any reason it was necessary to bring a camera indoors, all this moisture had to be carefully wiped away; and the greatest care had to be taken to see that none got inside a lens. To do so much as breathe upon a lens in the open air was to render that lens useless, for it instantly became covered with a film of ice which could not be removed. It had to be brought into the warm air and thawed off; then wiped dry . . .

Great care was required to prevent plates being ruined before use. There was not sufficient room in the Hut to store my entire stock, so the supply in the darkroom was replenished, from time to time, from the stores outside in the snow. Plates had to be brought indoors gradually, in order to prevent unsightly markings. This took two days . . .

To thread a film into a kinematograph camera, in low temperatures, was an unpleasant job, for it was necessary to use bare fingers whilst doing so. Often when my fingers touched metal they became frostbitten. Such a frostbite feels exactly like a burn. Once, thoughtlessly, I held a camera screw for a moment in my mouth. It froze instantly to my lips, and took the skin off when I removed it. On another occasion, my tongue came into contact with the metal part of one of my cameras, whilst moistening my lips as I was focusing. It froze fast instantaneously; and to release myself I had to jerk it

away, leaving the skin of the end of my tongue sticking to the camera, and my mouth bled so profusely that I had to gag it with a handkerchief.[29]

On one occasion Ponting summed up Antarctica as a 'very disappointing region for photography'. By this he meant that the weather and numerous other difficulties prevented the extensive and optimum coverage on which he had set his heart. In fact those difficulties are an integral part of human existence in the Antarctic and shape both man's reactions to the continent and the manner in which he records it. Thus the record must show nature at its most beautiful and terrifying and man supremely contented and yet driven to the limits of his endurance—and sometimes beyond. Whatever doubts he may have had, Ponting's photography captured these extremes to perfection. Frank Hurley's description of him as 'the leader in Antarctic photography' was an unchallenged statement of fact.

[1] The carbon process was greatly favoured at this time for exhibition purposes and the best portraiture. Carbon tissue—paper coated with a layer of carbon or coloured pigment in gelatine—was sensitized and exposed. The exposed gelatine became insoluble in water, but the unexposed or still soluble gelatine was removed by rinsing in warm water. The resulting range of tones was very wide and the prints could be made in a number of colours. Ponting wrote to a friend in 1926: '(It is) the finest and most permanent photographic process known.'

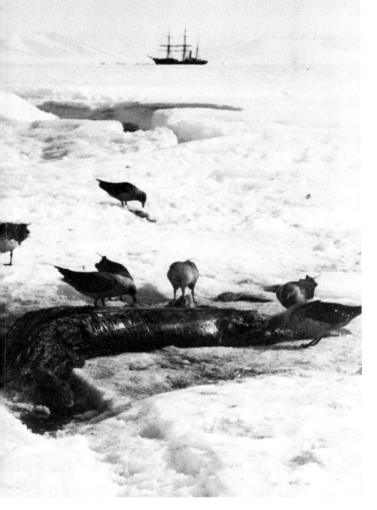

A moment to relax. In both his still and movie photography, Herbert Ponting demonstrated the infinite patience, application and disregard of discomfort and danger required of the dedicated photographer

Appraisal

Herbert Ponting prided himself on his great technical competence in photography and yet at the same time regarded himself not as a 'photographer' but as a 'camera artist'—and it was as the latter that he was officially recorded in the roll of the Antarctic Expedition of 1910–13.

As distinct from other photographers who were—and still are—noted more for their philosophizing on photography than for their practical results, Ponting scarcely wrote one word on his philosophy of photography. A camera magazine put it well in 1925, however, when it commented: 'He is at once a pictorialist and a recorder of truth—an uncompromising champion of the school of "straight" photography.' He well knew the effects which could be obtained by the manipulation of equipment and sensitized materials—none better. But if he belonged to a 'school' it was among those photographers who almost without exception used very small apertures to achieve extreme depth of field in their photographs. It is difficult to find one photograph in which he chose to make use of the technique of 'differential focus' whereby parts of a picture are deliberately thrown out of focus.

There is no record that Ponting had any formal art education—and his photography was self-taught. But he did have an instinctive feel for composition and lighting. Out of the many comments upon his work, there are a few which it can be assumed with some confidence he greatly cherished—as, for example, when the magazine *Colour* wrote that 'Many of Mr Ponting's pictures possess qualities which are only looked for in the work of great painters'; when the art critic of the *Daily News* observed: 'Mr Ponting has now succeeded in obtaining for photography all the acknowledgements which previously were reserved for drama, painting and literature'; and when Sir John Lavery R.A. said after looking at a Ponting portfolio: 'If I were to have painted any of these scenes, I would not have altered either the composition or the lighting of any of them in any way whatsoever.'

It is important to realize, however, that Ponting was not striving to imitate the painter. In using his great technical photographic skill to record a scene, he strove after what he considered 'felt' right and represented its mood. If there were close similarities between certain aspects of this interpretation and that of a painter, then this might be gratifying, but there was no evidence that Ponting would have changed his attitude if things had been completely otherwise.

He was far from being the first talented or specialist photographer to travel the world or to be officially appointed to an expedition. The Frenchman Désiré Charnay was photographing Mayan ruins in Mexico in the late 1850s at about the same time as the highly successful English photographer Francis Frith was on his numerous journeys to

[2] *The Weekly Press*, 23 November 1910

[3] H. and A. Gernsheim: *A Concise History of Photography* (Thames and Hudson 1965). See also Beaumont Newhall: *The History of Photography* (Museum of Modern Art, New York 1965) and Brian Coe: *George Eastman and the Early Photographers* (Priory Press 1973)

[4] E. O. Hoppé: *Hundred Thousand Exposures* (Focal Press 1945)

[5] Ibid

[6] *The Weekly Press*, 23 November 1910

[7] The then Lieutenant-General Sir Ian Hamilton, in his book on the Russo-Japanese War (*A Staff Officer's Scrapbook*: Edward Arnold 1906) recorded the correspondents' extreme dismay at this Japanese policy. He also had to struggle hard before he was allowed near the action. Frederic Villiers of the *Illustrated London News* was another observer of the siege of Port Arthur. He industriously made numerous keyed sketches of the scenes on the Japanese side and the *I.L.N.* gave him the by-line of 'Our Special and the only Artist Before Port Arthur'. His experiences are briefly recounted by Pat Barr in *The Deer Cry Pavilion* (Macmillan 1968)

[8] *The Great White South*: Herbert G. Ponting (Gerald Duckworth 1921) p. 5

[9] *The Deer Cry Pavilion*, p. 171

[10] *In Lotus-Land Japan*, p. 22 (All quotations are from the 1922 edition published by J. M. Dent)

[11] Ibid., p. 33 [12] Ibid., p. 62 [13] Ibid., pp. 67–68 [14] Ibid., p. 258

[15] Ibid., p. 38 [16] Ibid., pp. 68–69 [17] Ibid., pp. 129–130 [18] Ibid., pp. 106–107

[19] Ibid., p. 118 [20] Ibid., p. vi

[21] If he knew of it, Ponting certainly would not have agreed with the Japanese proverb: 'There are two kinds of fools—those who never climb Mount Fuji and those who climb it twice.' (Quoted in *The Deer Cry Pavilion* pp. 170–171.)

[22] Ibid., p. 232 [23] Quoted in *The Great White South*, pp. ix–x

[24] *The Great White South*, pp. 40–41

[25] *The Photographic Journal*, March 1935 [26] Ibid., pp. 83–84

[27] Ibid., pp. 70–71 [28] Ibid., pp. 217–219 [29] Ibid., pp. 168–170

Egypt, Palestine and Syria as well as to Asia. In the 1860s and early 1870s John Thomson—a Scot who was later to achieve fame by his photographic studies of *Street Life in London*—published works on China, Siam and Cambodia after a ten-year stay in the Far East.

The first photographs of the Alps were taken within a few years of the invention of a practical photographic system and William England, J. A. and C. M. Ferrier, Adolphe Braun, the Bisson brothers and Aimé Civiale are just a few of the names from early Alpine photography. In the 1860s, amateurs and professionals like Philip H. Egerton and Samuel Bourne respectively took probably the first ever cameras into the Himalayas, while across the world photographers such as William Henry Jackson and Timothy H. O'Sullivan were recording with great skill the frontiers of the American west and elsewhere. Nearer to Ponting's own time Vittorio Sella combined climbing with photography in a manner which made his name famous.[1]

In the photography of subjects in which he specialized and the challenge from contemporaries, Ponting's skill has withstood the final and undeniable test—that of time. In portraying Japan, he was preceded by Felix Beato (who published *Photographic Views and Costumes in Japan* in 1871 and who has been described by F. Saito[2]—a distinguished critic of photographic history in Japan—as a photo-journalist many years ahead of his time); by Francis Frith; and by yet another Briton, W. K. Burton. However, partly because it was only portraiture that paid in Japan, none rivalled Ponting as a landscape photographer and certainly none before or since surpassed his superb photography of Mount Fuji—photography which elicits admiration from Japanese critics today just as it did when first published. And Ponting's claim that he 'discovered' Fuji as a photographic subject still holds true.

As to photography elsewhere in Asia, research has failed to reveal a contemporary of similar stature to Herbert Ponting although two agency photographers—James Ricalton and J. H. Hare—did excellent work during the Russo-Japanese War and Ricalton also published a collection of photographs under the title *India Through the Stereoscope*.

In Antarctica, Ponting became the very first specialist still and movie photographer to go to a polar region and almost certainly the first movie cameraman to use the instrument for naturalist studies. Whilst he is chiefly remembered for his Antarctic work, the photographic skills which he demonstrated there were but an albeit powerful display of what had gone before in Asia—and on which his photographic reputation still stands: splendid technical and compositional talents which could occasionally rise to the heights of true photographic greatness. That this is the case is classic proof of the great and timeless value of the

'seeing eye' above all else, for generally the quality and versatility of Ponting's equipment and materials could not compare with those of today.

And what of the man? His good qualities were numerous. He was generous, touchingly enthusiastic and quick to appreciate the merit in others. He had a profound love for his own country but an equally profound appreciation of the attributes of other nations. He was brave himself and respected bravery in others. Above all, he was loyal—to a fault. He was capable of immense application and of displaying great stamina. He was stubborn in achieving the goals he had set himself and his patience was limitless. And, in the word of the time in which he lived, he was a 'gentleman'.

The seeds of his weakness were in these good qualities. He was too serious and inflexible. He was highly strung and incapable of making close and intimate friendships from which he could derive as well as give strength. Although he made superficial acquaintances easily and had the agreeable social manners of a member of the upper middle class, he was at heart a 'loner'. He had a quite erroneous belief in his business acumen despite failure after failure. He was quite incapable of realizing and analysing his own faults and the failure of any of his projects was always attributed to the errors or plots of others, or to their inability to see the truth which had been revealed to him so clearly. Ponting was incensed at the way in which the photography he had taken in Antarctica was handled by agents acting for Scott, and he bitterly regretted not having entered into a detailed agreement before the expedition sailed. After returning to Europe – not knowing that Scott was already dead – he poured out his feelings in a letter to him:

It cannot be helped now, but words utterly fail to express my disappointment and chagrin, as though the work I have done in the South is the most difficult, and perhaps the most valuable that I have ever done, from the Geographical standpoint, yet I am unable to reap any benefit from it in the quarter where it would do me most good. I did not go to the South to win my spurs, as many others did, and as perhaps you thought I did. I won them long ago. I went South because I thought this work worthy of the skill which I had been acquiring in many lands, and by many years of travel. I now see that it was folly of me to decline the best offer of my life to go on this Expedition, for as things have turned out, I am debarred from reaping the benefit of what would have been to me one of the greatest assets from the work—its appearance in the illustrated papers of the whole world.

My work, I think I may state without boasting, is known all over the world, I am sending you a Graphic so that you may see what the Editor of that paper had to say about it, and I could show you other papers which have been equally flattering, the French and German as well as the English, and the American as well. I never dreamed that when this affair was fixed up with the MIRROR that it would practically come to mean, in the end, that that periodical and the STRAND would be the only ones

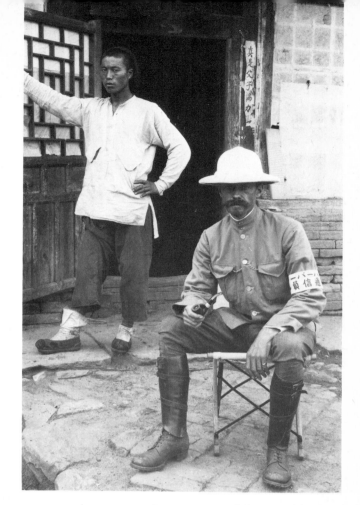

Ponting with servant in Manchuria during the Russo-Japanese War. His pass as a war photographer was in the form of an armband

to use my work. To come down from the best papers of the world to such as these, to which I have never before thought of contributing, is indeed a drop, and one that puts me in a very unenviable position.

I do think that you should have let me know that you were leaving matters in such a condition that a change of plans, such as has occurred, was possible. I should certainly not have agreed to the suppression of my results in this manner, had I had any ideas that anything of the kind was likely to occur.

One cannot at my age, and with my responsibilities, give up important commissions, to go on an undertaking on which the conditions are largely a matter between man and man, and then find that these conditions are not observed, without making a very vigorous protest against the injustice of it.

I think that I made a very great mistake in going on this enterprise without a full and complete Agreement, such as I have had with every firm with whom I have previously dealt, and I certainly think you should have let me know in full, as I thought I did, of your arrangements for dealing with my work. I was never permitted to know anything about that detestable advertisement work until I got on the ship. Well, I did that to enable you to keep faith with all those people; now I come home to find that my work has been dealt with in a manner totally different from that for which I agreed to do it.

I have done this work with all the strength I possess, and I have taken great pride in doing it, as I think the undertaking such a splendid one, and I certainly consider it a privilege to have had the opportunity of doing it. Please do not think that I am dissatisfied in that respect. It is simply that I am so very disappointed at the non-appearance of my pictures in the papers.

I will tell you some of the ideas I had in mind. I felt that it was in my power, not only to let the world *see* what a grand and great undertaking this Expedition was, but to do the splendid fellows who were my comrades so long, a good turn at the same time. Those pictures of Simpson at his magnetic work, of Nelson at his water-bottle work, of Lillie at the trawl work, of Evans at the astronomical work, of Simpson with his balloons, of Wilson and Bowers at those thermometers in the dark, of Atkinson at the fish-trap, of Day and his motors etc., etc. would all have made fine illustrations and would have been used full-page. It would have been a good thing for them, and would have helped very largely to make their work better known. I should have taken a keen delight in thus doing them a good turn. Even the contemplation of it gave me a great deal of pleasure, in the South.

. . . . To get back to the films . . .

You may, I think, safely figure on another two or three thousand pounds, in addition to the sum already received, so that I hope you will, after all, not think that I have been such a bad investment. I mean that out of your share of the receipts, you ought to get something like £6/7000, perhaps more. If Mr Amundsen had not turned up, there is no doubt that the sum I have always named to you,—£20,000 might well have been reached. However, this part of the thing we can take in sporting spirit. . . .

I am sending you a copy of a letter that I have just received from Prince Louis of Battenberg, which will show how interested he was in the show of the films. He

was very nice to me, and got me to explain everything to him. He was especially interested in the picture of you getting into your sleeping-bag. That one always brings down the house. That film has puzzled even the trade to know how it was done. I think you will be very pleased with it. It makes them all laugh, because Birdie goes through such funny antics; that, and the film of you & Co doing the sledging, are always voted by everyone the best things in the show . . .

I am wondering what is going to be done about my expenses. I recently sent in an account for them up to the middle of Oct. I had a letter from Sir Edgar Speyer's secretary stating that Sir E. was going to Germany and could not reply about them. Why reply at all, why not send the cheque and be done with it? I am out of pocket to a great deal more than the account that I sent in, and the profits from my work have surely been sufficient to far more than cover them and leave some thousands to boot . . .

Even his dedication and application became a weakness when he completely failed to see that the world had little use for the manner in which he planned to perpetuate the memory of Captain Scott and the Polar Party—a memory, anyhow, which he had already assured many years before. His personal deficiencies fed one upon another and he died a financially poor, spiritually lonely and embittered man.

But he had conceived his grand visions of reality—and in one, all too short period of his life, recorded them for all to see and enjoy, then and later. Which of us would not be proud to leave such an enduring legacy?

[1] H. and A. Gernsheim: op. cit. pp. 97–104

[2] *A History of Japanese Photography: British Journal of Photography Annual 1972* (Henry Greenwood)

Landscapes

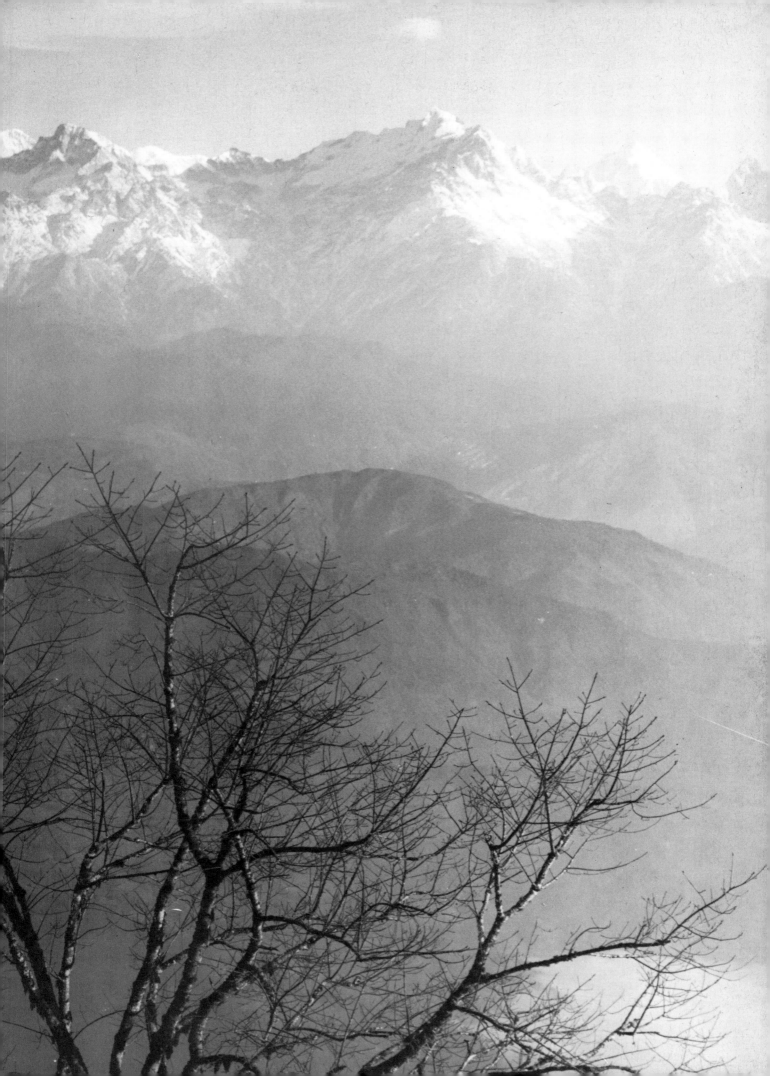

Previous pages: The Kanchenjunga massif in the Himalayas—a fifty-mile telephotograph from Darjeeling

Below: Negotiating a crevasse in the Alps
Right: Evening – the Matterhorn from the Stellisee

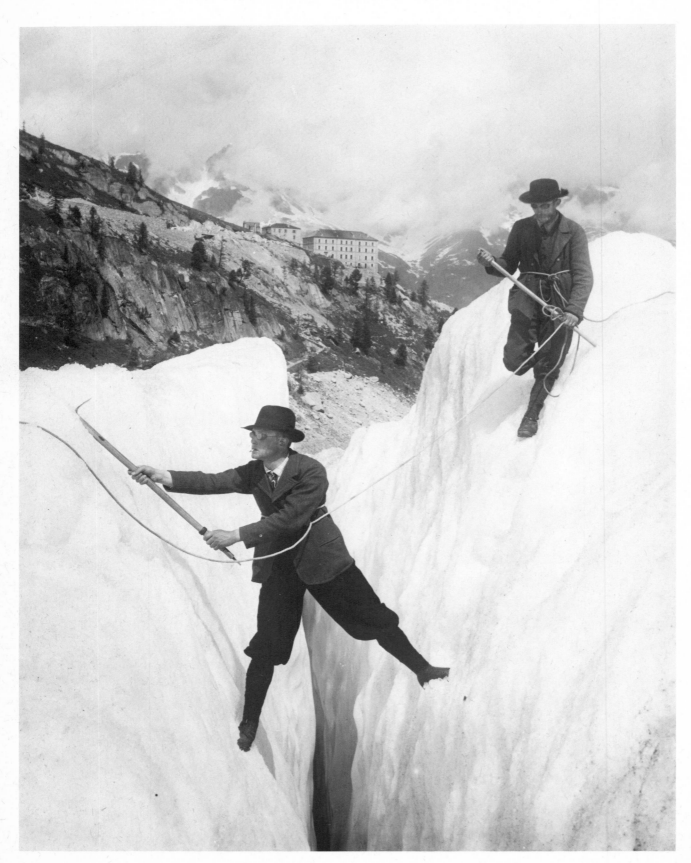

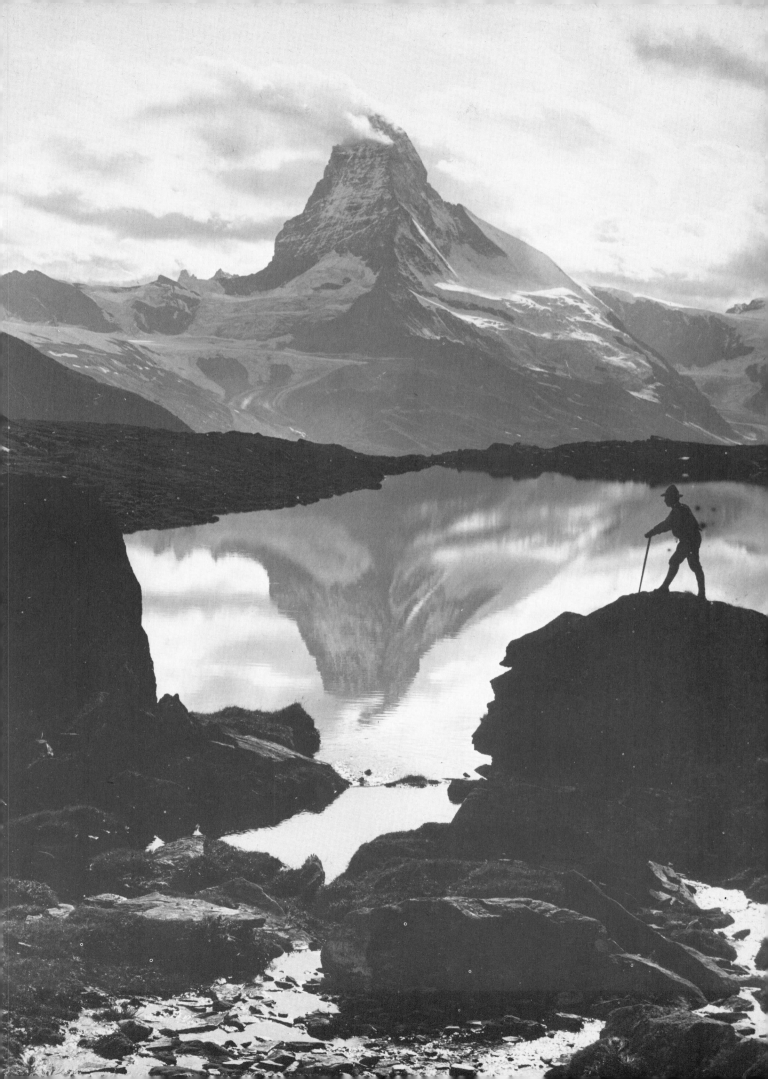

Swiss climbers in prayer before an ascent of the
Matterhorn

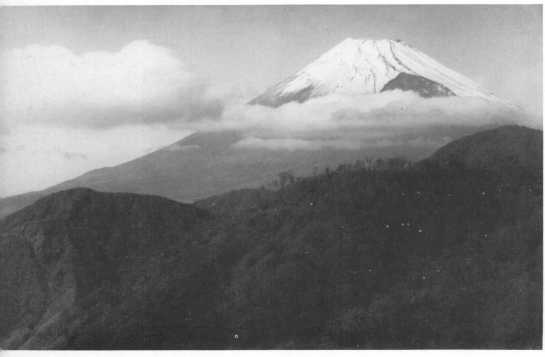

'[The] delicate outline of that loveliest of all mountains of
the earth—that wondrous inspiration of Japanese art,
Fuji-san—was softly painted on the western skies . . .'

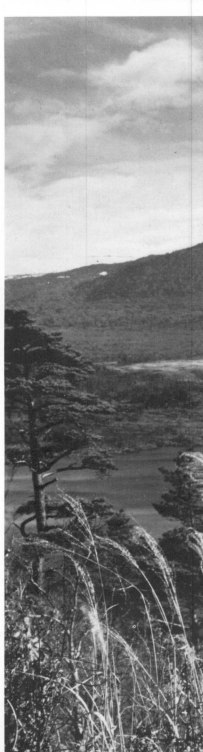

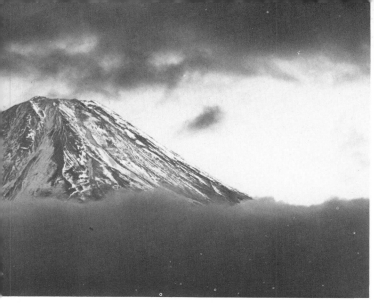

Left: Fuji through a rift in the clouds—a powerful composition which isolates the mountain peak from the surrounding countryside

Below: Mount Fuji and the Kaia grass. After tramping 14 miles to a particular spot more than a dozen times to secure this photograph 'the long awaited moment really came. The mountain was clear; for a few brief seconds the grass was still, and during them I secured the coveted picture—which depicts the mountain in early winter'

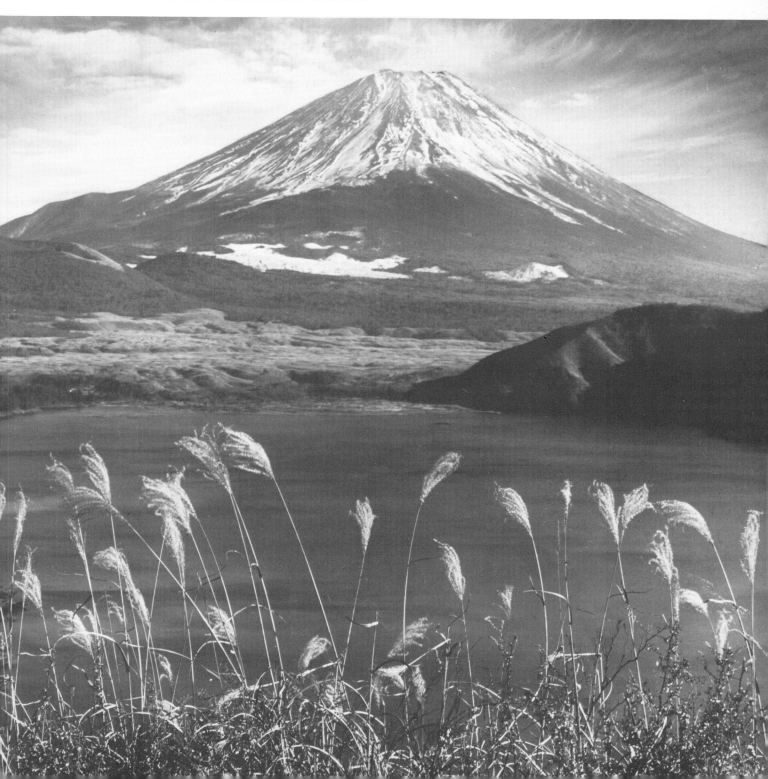

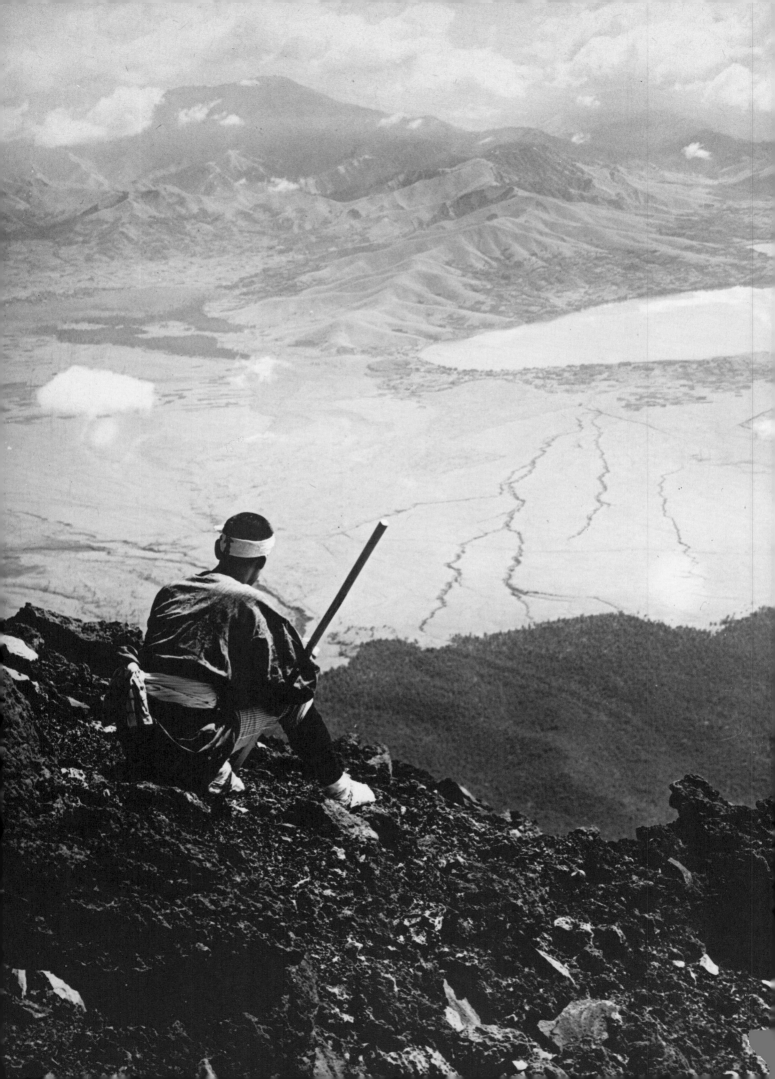

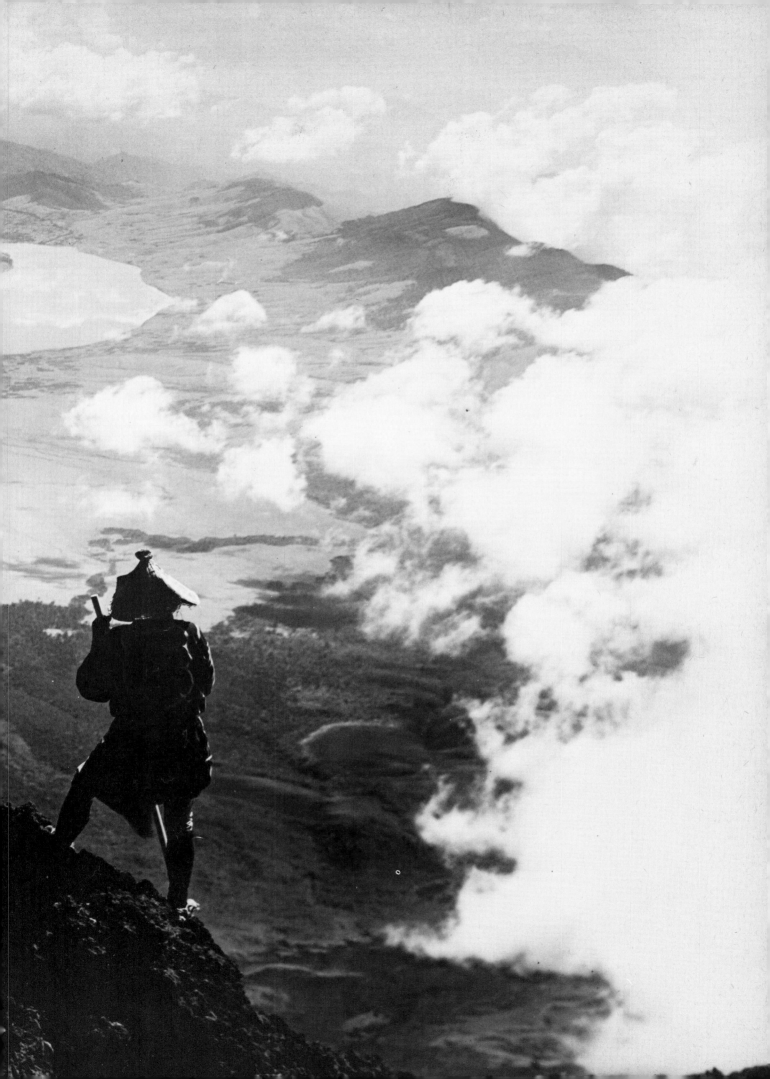

Previous pages: Lake Yamanaka from the summit of Fuji. The lake was also called Mika-dzuki Kosui or 'Three-Days'-Moon Lake' because of the similarity of its shape to a crescent moon

Fuji between the pines at Lake Motosu. 'Though I have visited [it] at least a score of times, as many more would not serve to cool my ardour for its beauty. It is the pearl of Japanese lakes . . .'

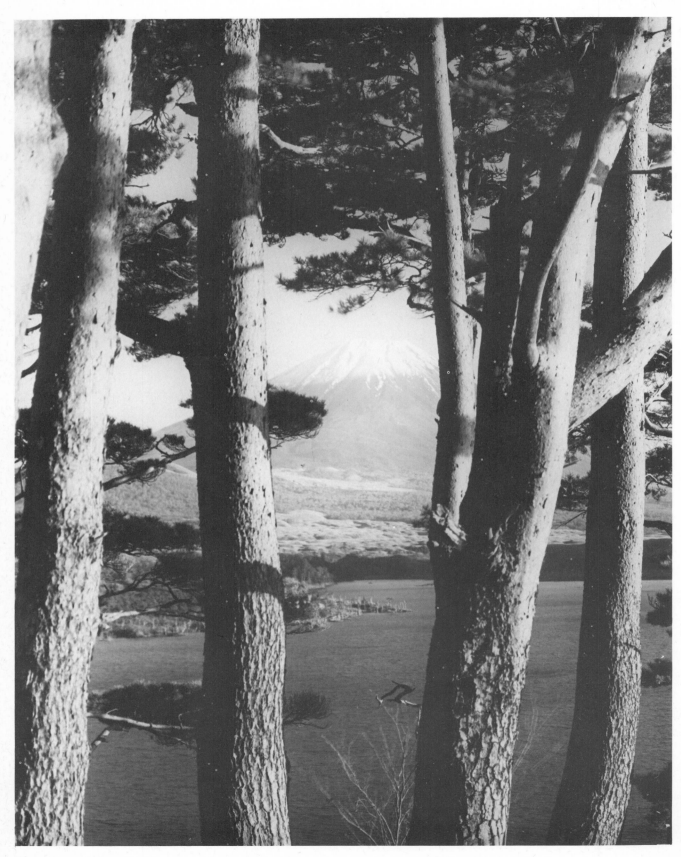

Japanese waterfall—a favourite subject for Herbert Ponting's cameras

Following pages: Sunset from the summit of Mount Fuji. 'When the sun sank to the level of the surging vapours, flooding their waves and hollows with ever-changing contrasts of light and shade, the scene was of indescribable beauty. I have never seen a spectacle so replete with awesome majesty as the sunset I witnessed that evening . . .'

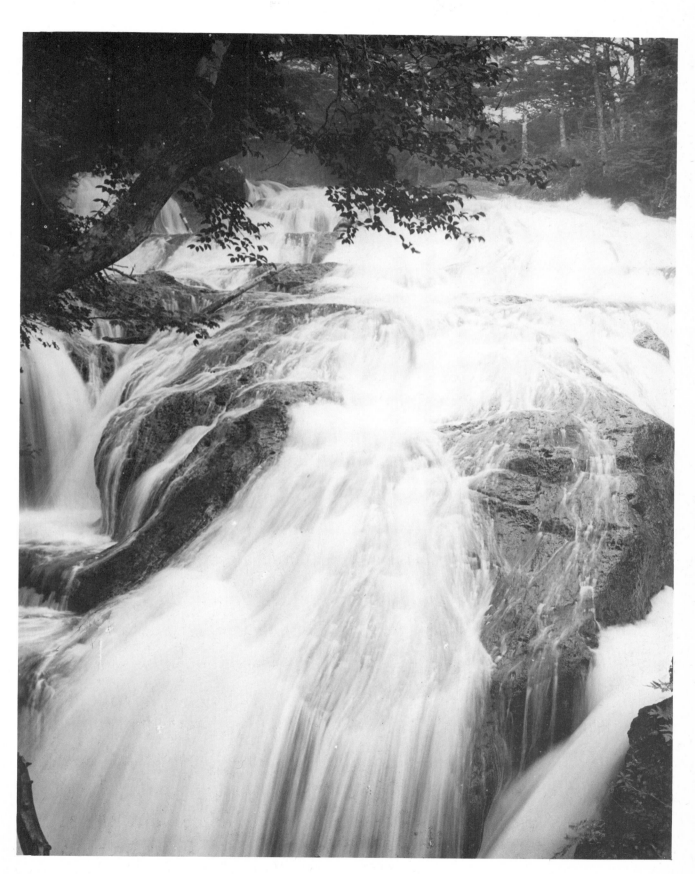

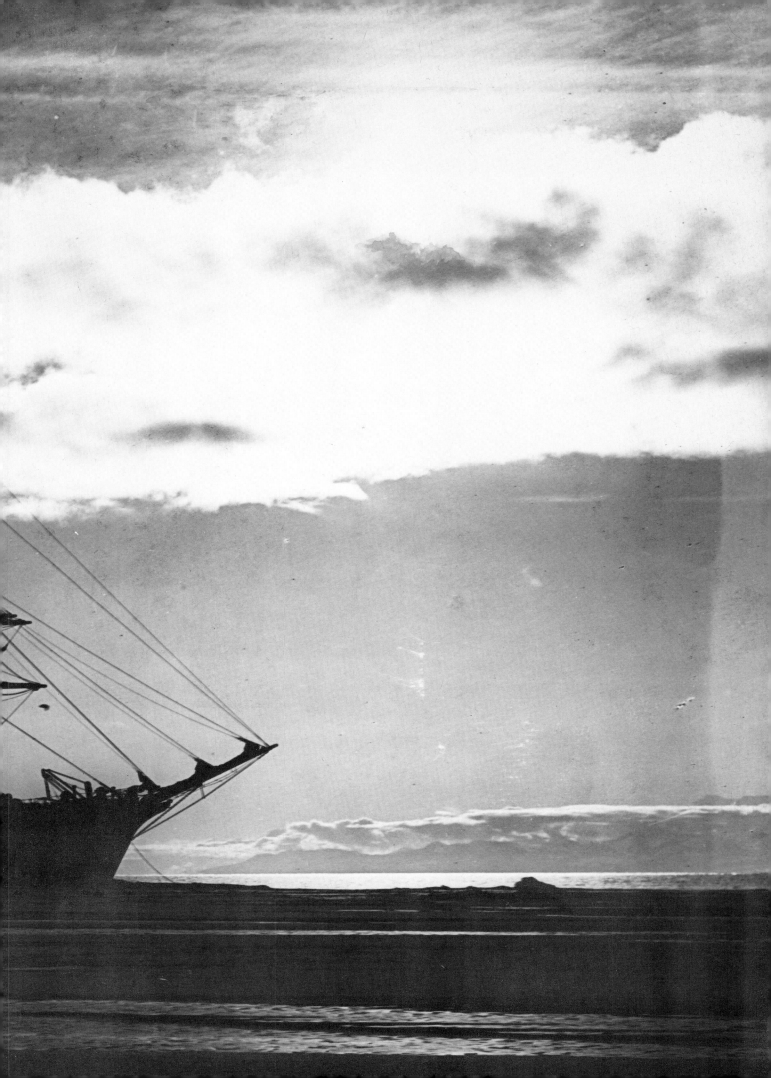

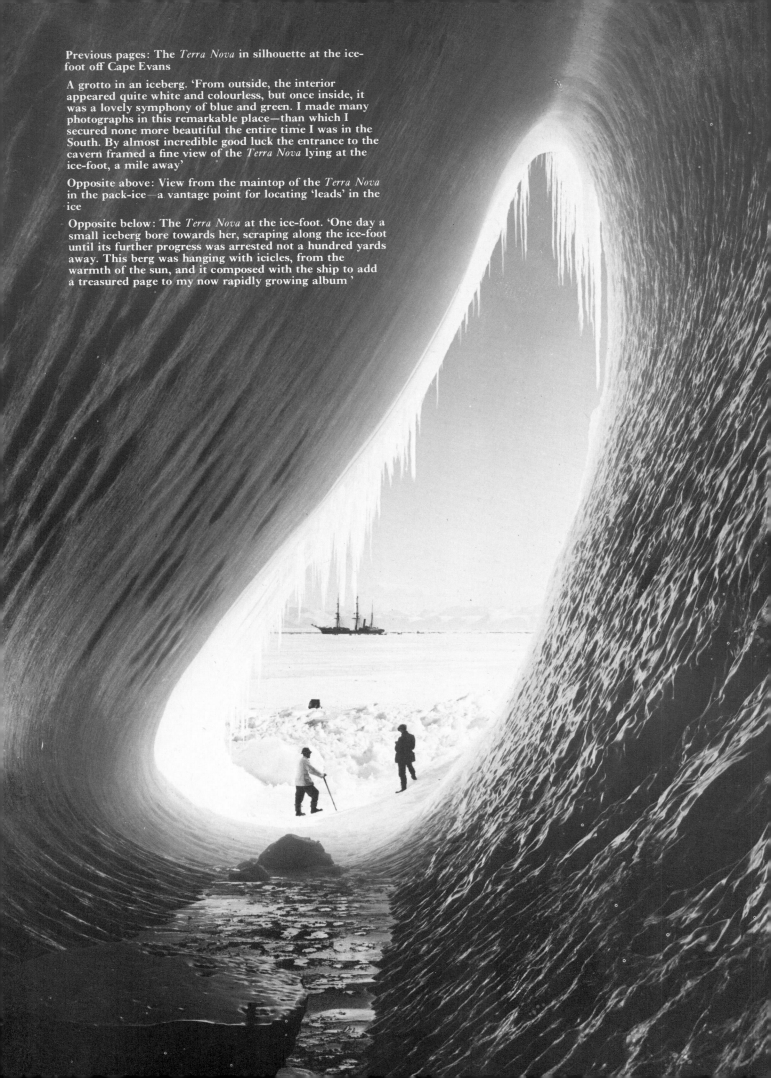

Previous pages: The *Terra Nova* in silhouette at the ice-foot off Cape Evans

A grotto in an iceberg. 'From outside, the interior appeared quite white and colourless, but once inside, it was a lovely symphony of blue and green. I made many photographs in this remarkable place—than which I secured none more beautiful the entire time I was in the South. By almost incredible good luck the entrance to the cavern framed a fine view of the *Terra Nova* lying at the ice-foot, a mile away'

Opposite above: View from the maintop of the *Terra Nova* in the pack-ice—a vantage point for locating 'leads' in the ice

Opposite below: The *Terra Nova* at the ice-foot. 'One day a small iceberg bore towards her, scraping along the ice-foot until its further progress was arrested not a hundred yards away. This berg was hanging with icicles, from the warmth of the sun, and it composed with the ship to add a treasured page to my now rapidly growing album '

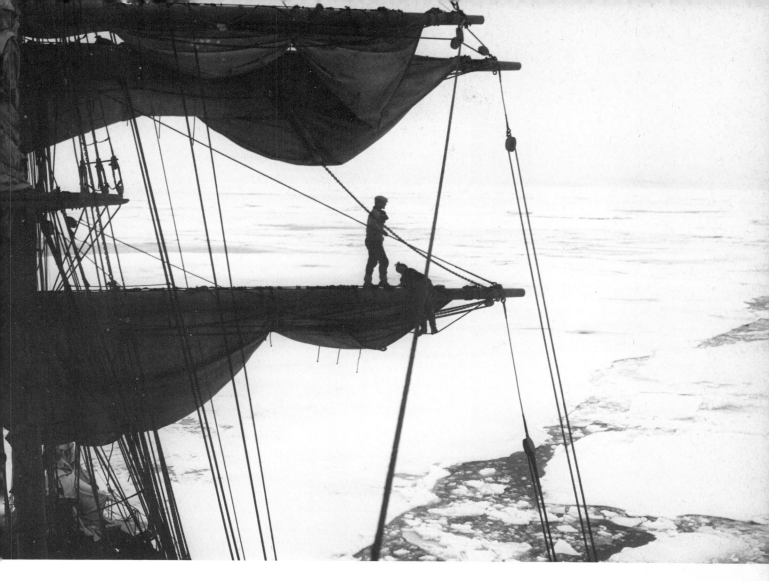

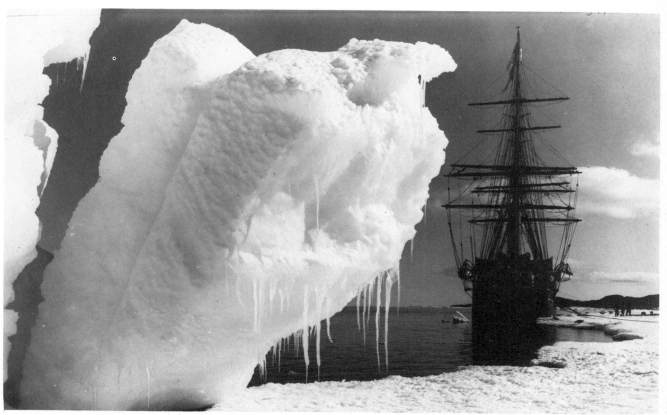

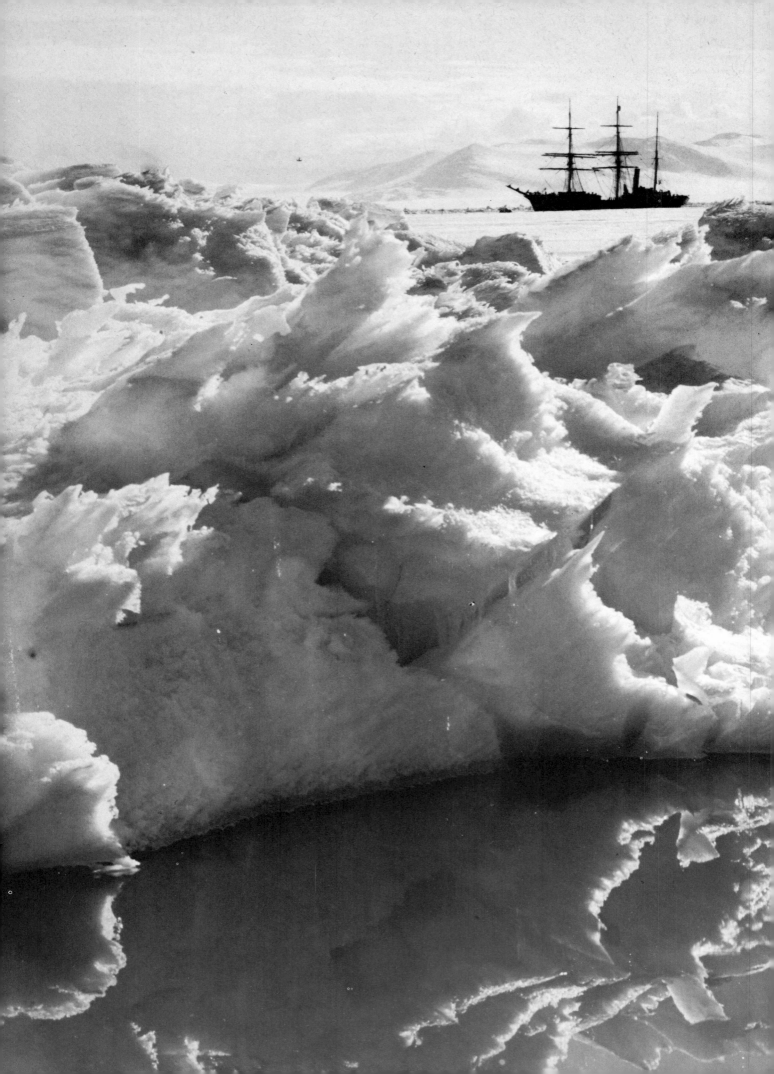

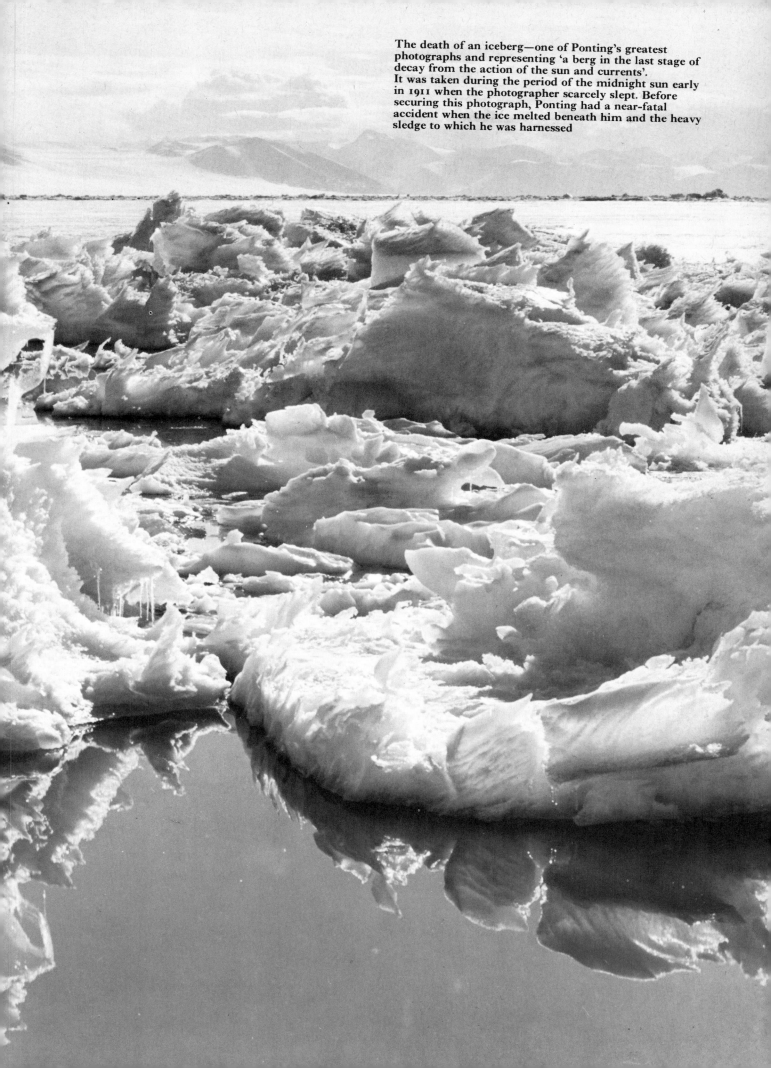

The death of an iceberg—one of Ponting's greatest photographs and representing 'a berg in the last stage of decay from the action of the sun and currents'. It was taken during the period of the midnight sun early in 1911 when the photographer scarcely slept. Before securing this photograph, Ponting had a near-fatal accident when the ice melted beneath him and the heavy sledge to which he was harnessed

Right: Iceberg in the pack-ice—a telephotograph with geologists Frank Debenham and Griffith Taylor in the foreground

Below: A telephotograph of the 13,000 ft. Mount Lister, seventy miles away across McMurdo Sound. Photography with a long lens was difficult in the windy conditions which frequently existed in Antarctica but Ponting eventually managed to secure a complete twelve-picture panorama of the Western Mountains of which Lister was one

Far right: The Church Berg with the Western Mountains in the background. The icebergs around Cape Evans were a perennial source of fascination to Ponting

Below right: Penguins making for water. A less well known but nonetheless beautifully observed photograph

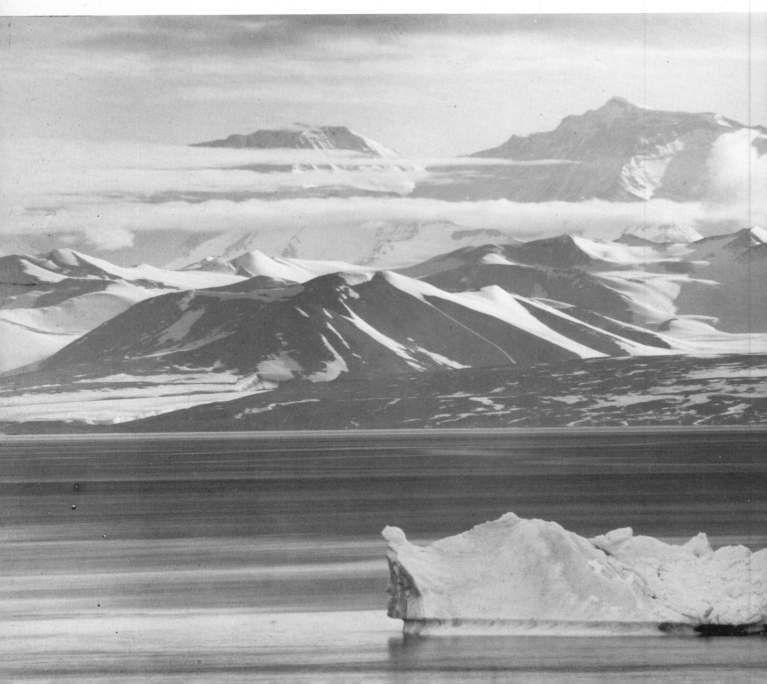

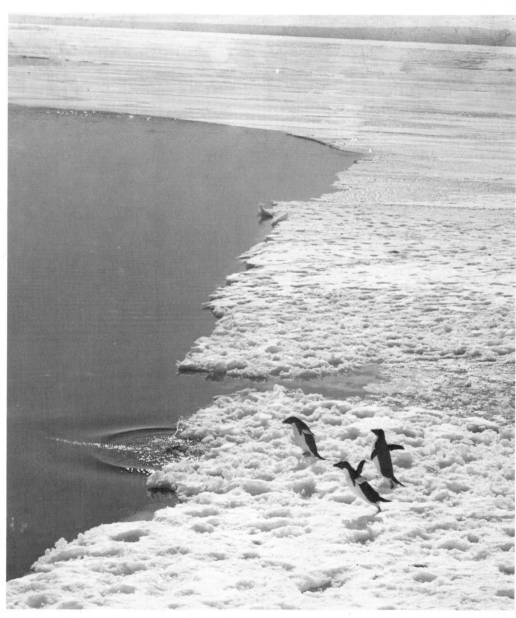

55

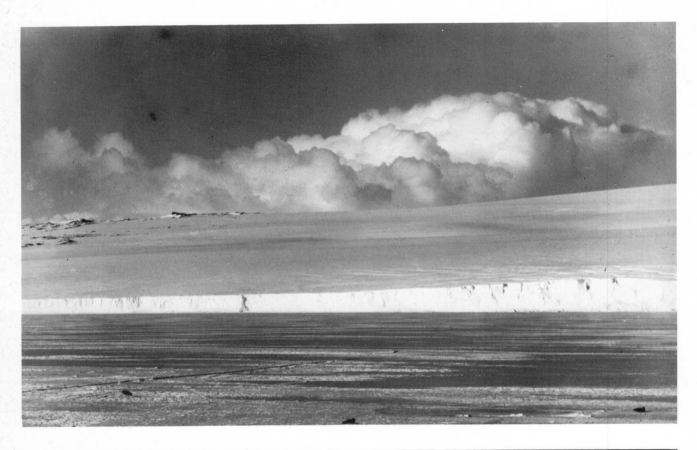

Christmas eve in the pack-ice from the *Terra Nova*. 'Not a
breath of wind ruffled the surface of the sea . . . A lone
Adélie penguin . . . stood on the floe for an hour, blinking
at the ship in wonder, until, warmed by the grateful rays
of the midnight sun and lulled by the silence that
prevailed, it tucked its head under its flipper and roosted
where it stood'

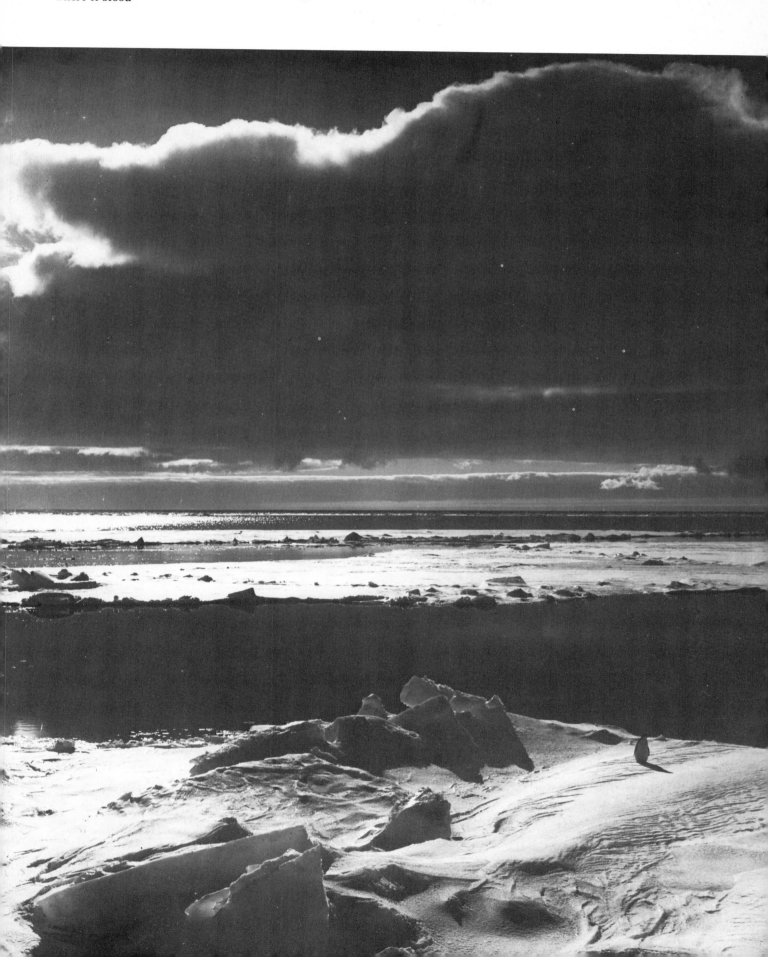

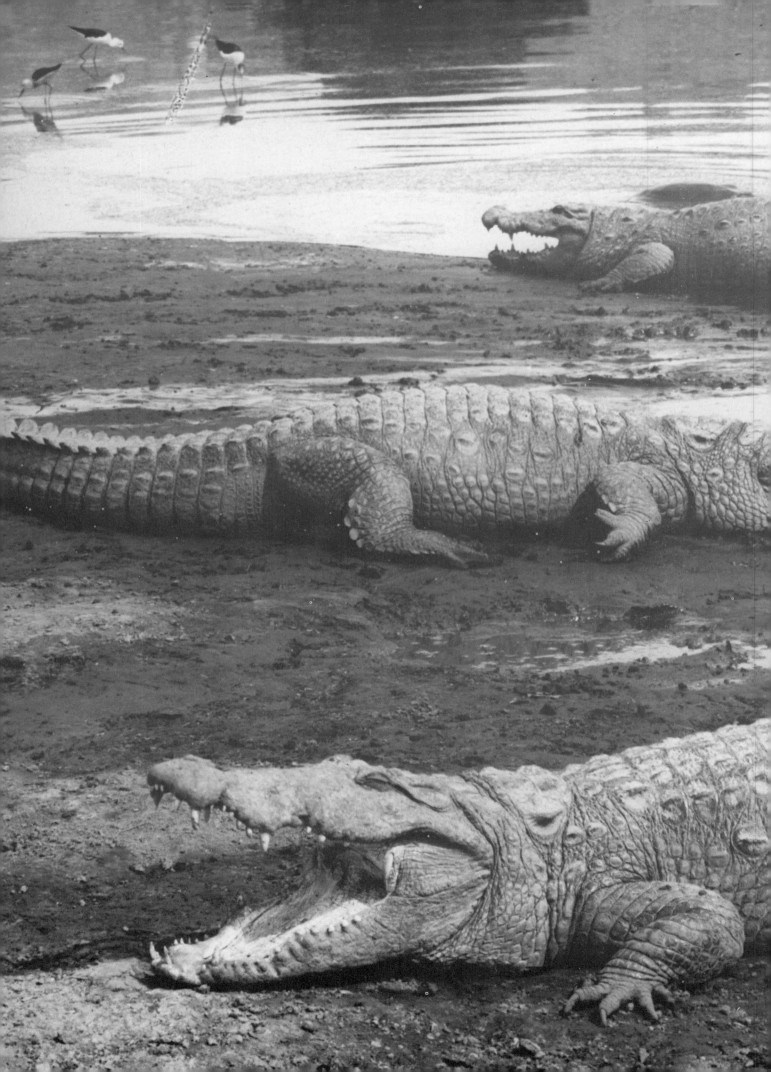

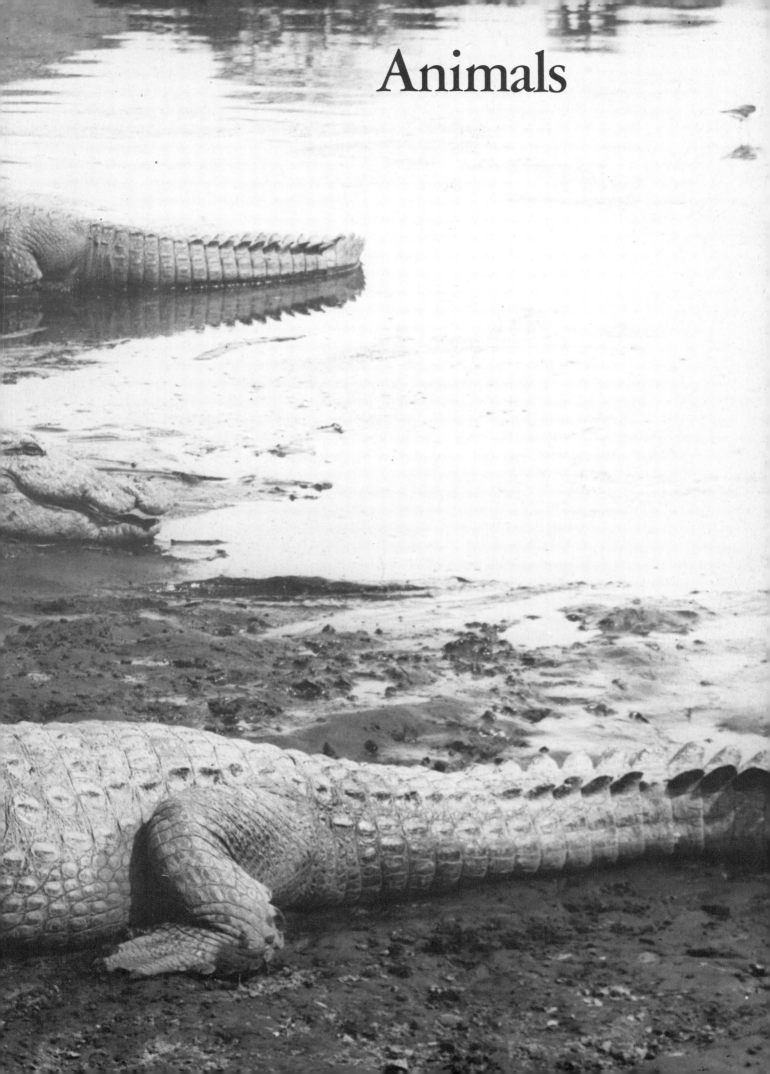

Animals

Previous pages: Photographing alligators in India, about 1906. This was yet another occasion on which Ponting's determination to get the right photograph almost led to a serious accident or his death. '. . . I took a leap and then ran . . . the brute's jaws came together with a loud snap that fairly made my blood chill, as I realized that only my leap had saved me from being badly mangled, or . . . set upon by the lot of them and dragged into the lake'

Below: Elephant teak-logging in Burma

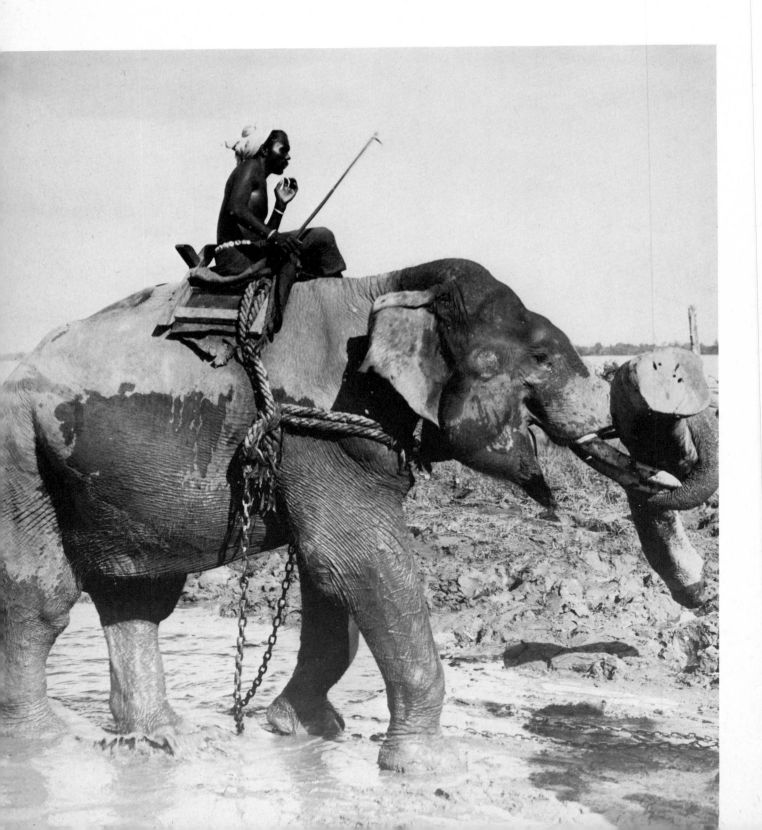

Vultures on the plains of India. On just such an occasion
Ponting wrote: 'I made a photograph of some hundreds of
these foul creatures tearing a corpse to pieces and another
picture showed the skeleton picked clean of every shred of
flesh '

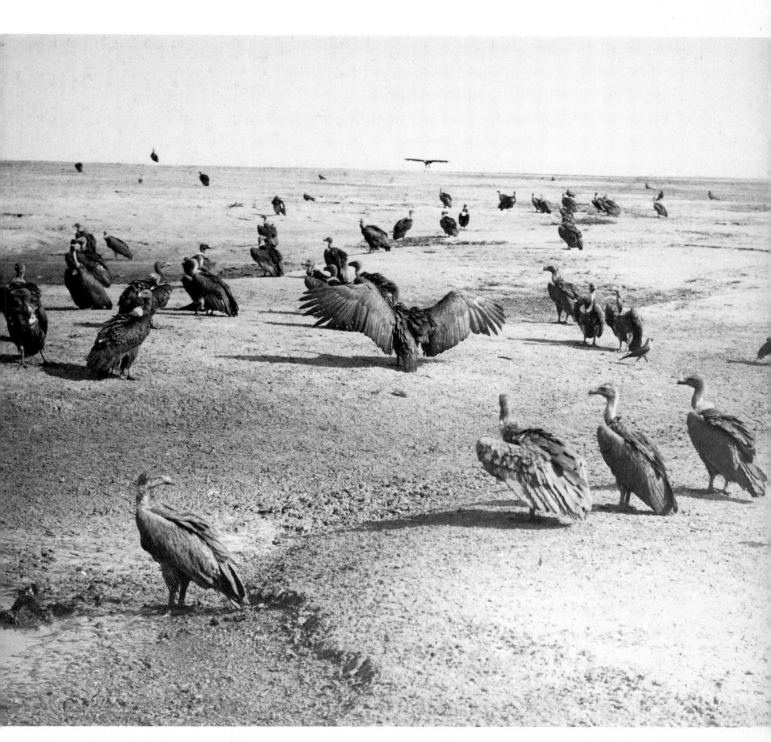

Carp in the lake at Kumamoto, Japan. 'The broiling
August sun glinted on the brown and azure wings of a
thousand dragon-flies . . . and great carp glided over the
gravel and in and out about the water plants, in water not
a dozen inches deep '

Below: Antarctica – An advertising photograph for one
of the sponsors in England

Bottom: Penguin with chicks. 'As the chicks grew, they
became a constant source of anxiety to their parents, who
were hard put to it to feed and protect them from harm;
for the ever-watchful skuas were always on the alert . . .'

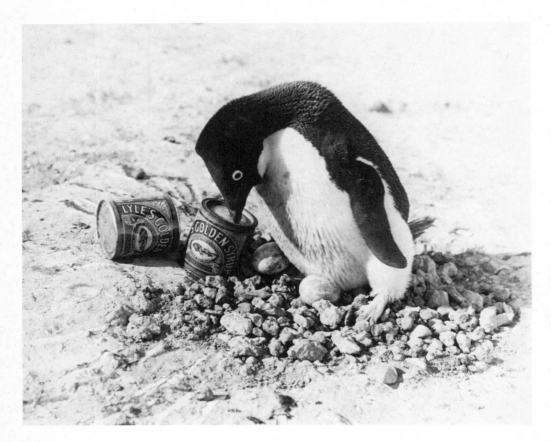

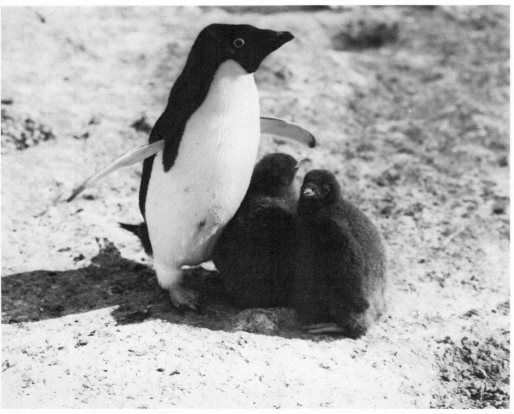

A skua-gull feeding its chick— it 'would retch a few times and then vomit forth a mass of half digested food on the ground, which the chick would go for greedily.' Ponting repeatedly tried to secure a movie record of this procedure but the noise of the camera always frightened the parent bird away. On one occasion he was attacked by skua-gulls and received a sharp blow over one of his eyes

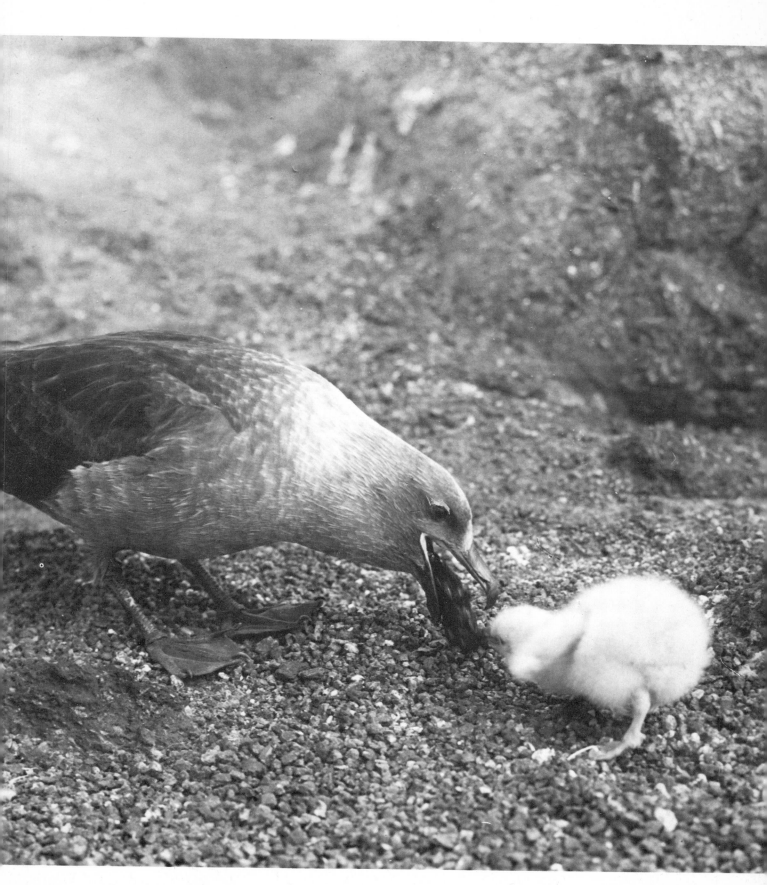

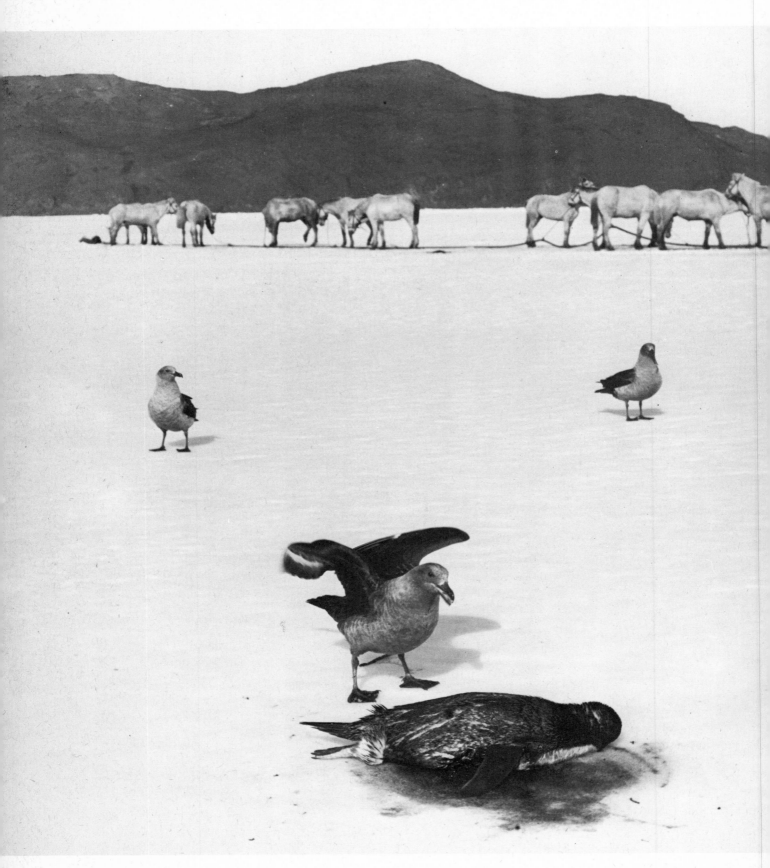

Skua-gulls, a dead penguin and ponies—an intriguing, almost surrealistic, composition and an unusual style for Herbert Ponting

Sledgedog Wolk—a beautiful creature 'who regarded me with contempt while I was taking his portrait'

A shark in the sea off New Zealand. Taken on the voyage back from Antarctica in 1912, the photograph showed that Ponting's eye for composition and pattern was as sure as ever

Right: A killer whale sounding. 'The last whale that I saw in the Antarctic excited in me almost as much awe as did the first, and I spent many interesting hours trying to secure moving pictures of them— which is anything but an easy task'

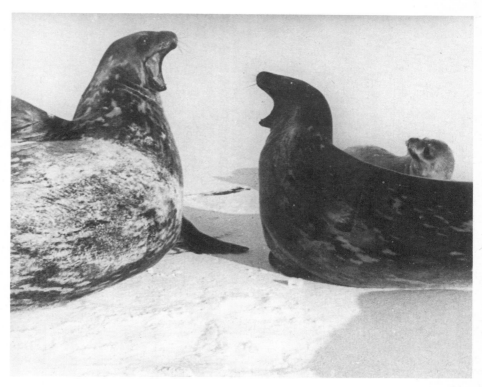

Weddell seals fighting. 'We seldom killed a bull seal that
had not deep scars on its hide, and it was easy to
distinguish those sustained in combat with their own kind;
they were quite distinct from the terrible . . . wounds
received in their adventures with the killer whales'

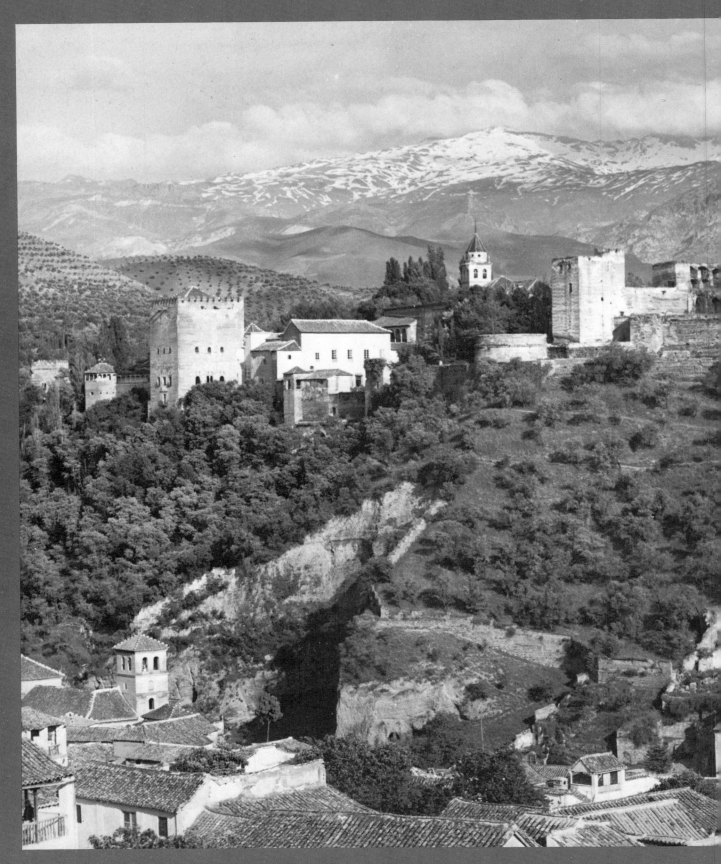

Temples and Palaces

Previous pages: The Golden Temple, Amritsar, India— the Darbar Sahib or sacred home of the Sikh religion. The upper part of the building is covered with gilded plates of copper and the lower part is of white marble

Below: The Jama Masjid or Great Mosque, Delhi. Over 200 ft long and 120 ft broad, it was built by the Shah Jehan in the first half of the seventeenth century. Its most precious relic was what was alleged to be a hair from the beard of the prophet

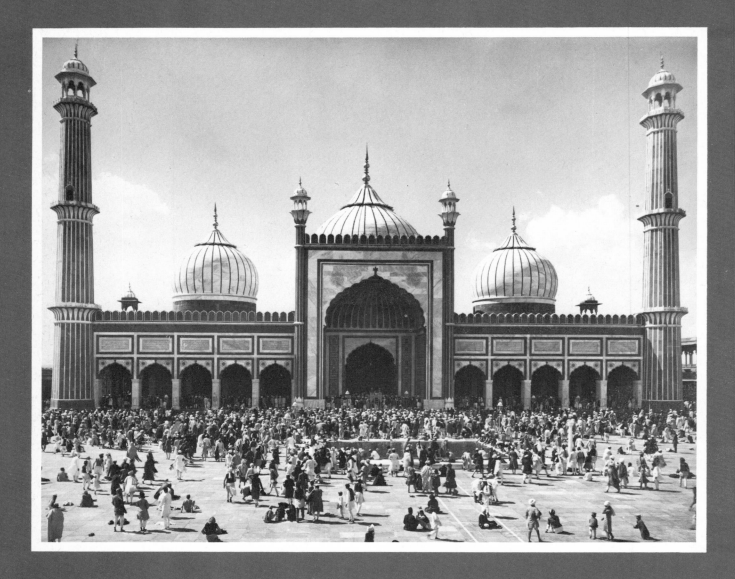

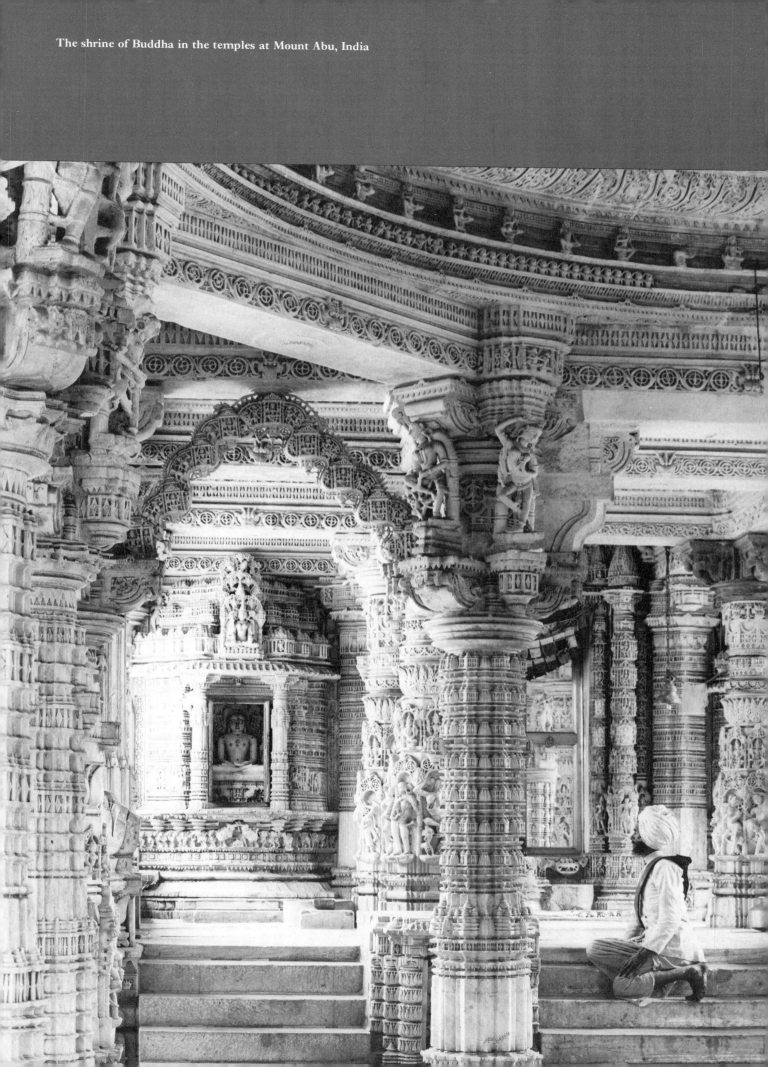

The shrine of Buddha in the temples at Mount Abu, India

All round the sides of the topmost terrace of Akbar's tomb is a cloister with walls of white marble trellis work

Opposite: The tomb of the great Moghul emperor Akbar in Agra, India. The tomb itself is in a garden which is reached through a gateway of red sandstone inlaid with white and coloured marble. Ponting isolated the gateway by framing it with the fine marble lattices of the mausoleum

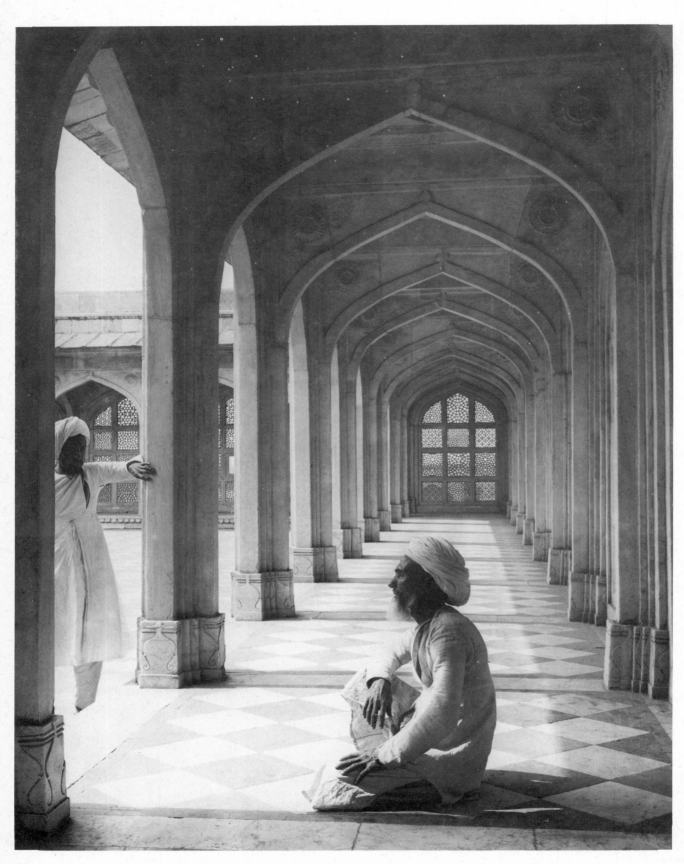

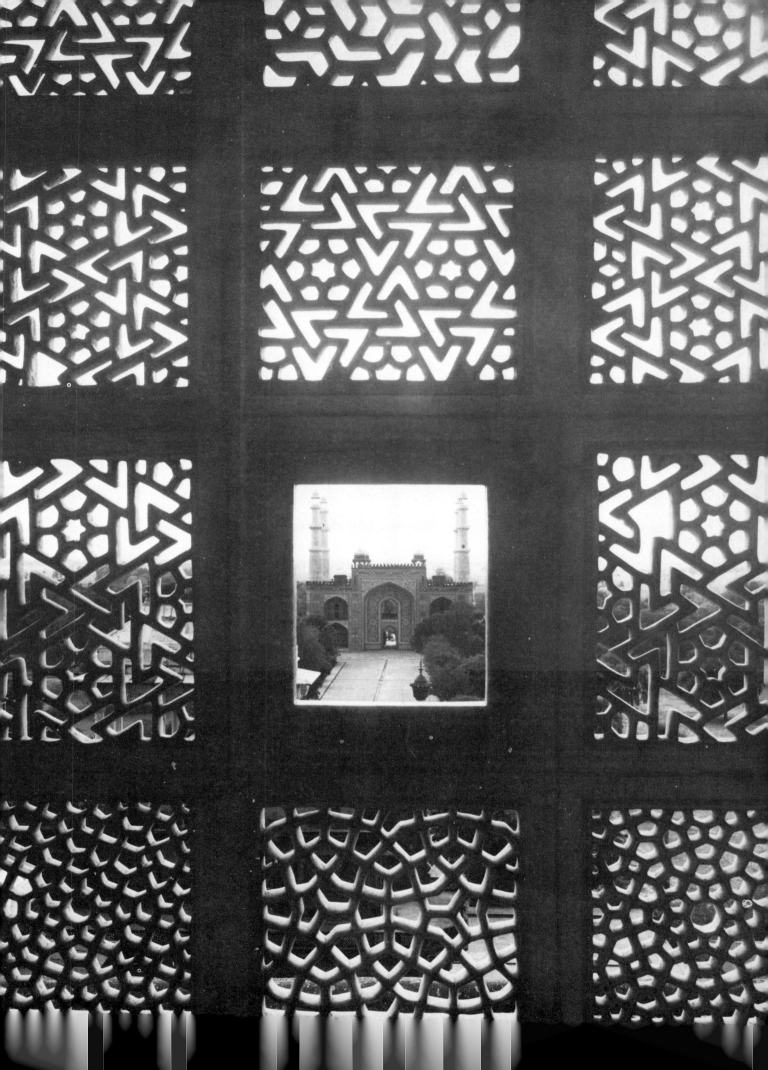

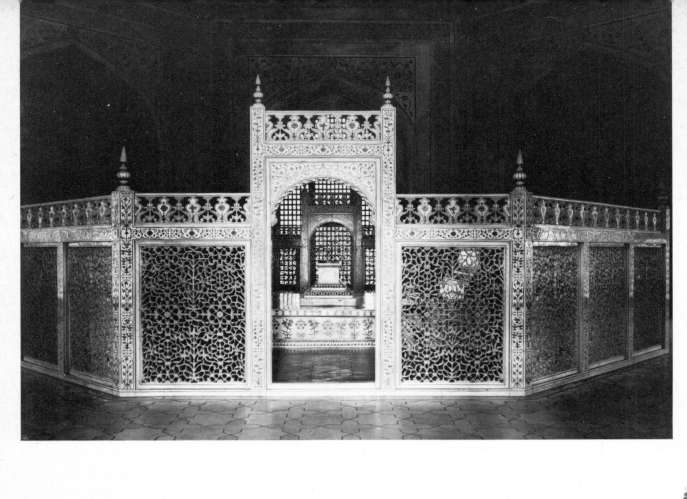

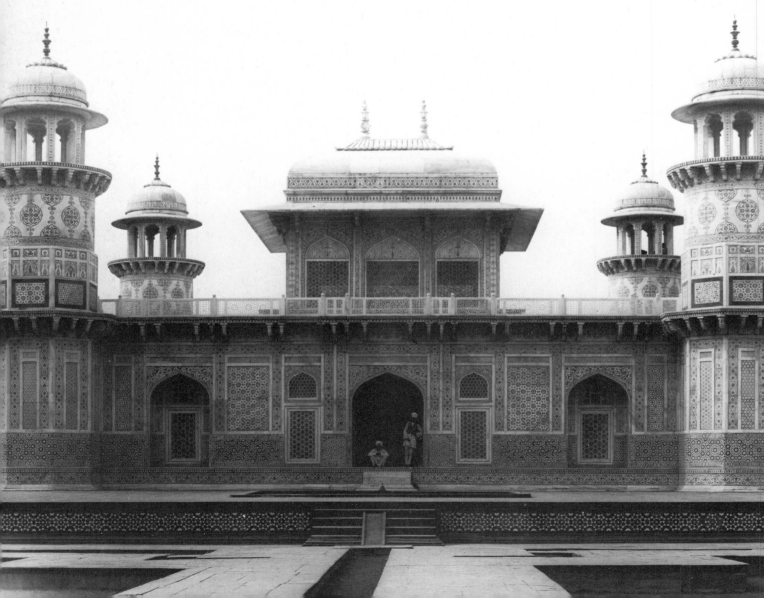

Left: Marble screen, Taj Majal, Agra. '. . . how can I ever tell you of that sainted chamber in which rest the bodies of the Shah Jehan and his Persian queen? How can I attempt to describe the delicate beauty of that trelissed marble screen, inlaid with precious stones, which girdles the tombs? . . . I have brought all the skill I can command to show in my pictures something of its ethereal beauty'

Below left: Tomb of Itamu Daulah, Agra, erected to a refugee Persian by his daughter who won a throne. 'I can only compare it to a delicately carved ivory jewel casket inlaid with gems. For beauty of design this building, to me, stands second to none that I have ever seen'

Inside the Great Buddhist Temple, Mount Minobu, Japan. Ablaze with colour and gold, it was frequently described as the most beautiful interior in the whole of Japan. The central altar—measuring 24 ft by 15 ft—was covered with scarlet lacquer decorated with gilded figures

Below and right: Ananda Temple at Pagan, the ancient capital of Burma. 'The Ananda is as beautiful as some of the first cathedrals of Europe . . . it dates from the eleventh century, its name being derived from the Sanscrit word *Ananta*—the Endless'

Far right: Shwé Dagon Pagoda, Rangoon, Burma. 'About the Shwé Dagon—that tapering golden finger piercing the turquoise sky by the great Irrawaddy—there is a delicious dream-like atmosphere, as one listens to its thousands of tiny gongs . . .'

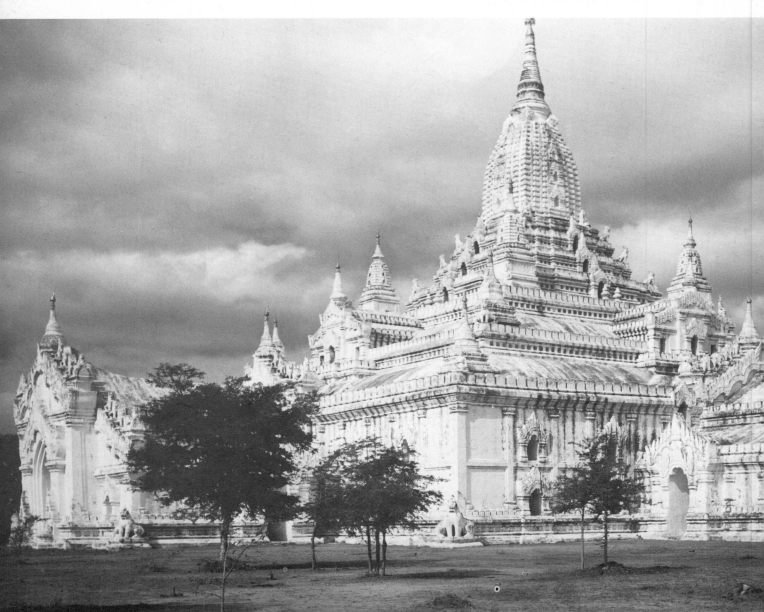

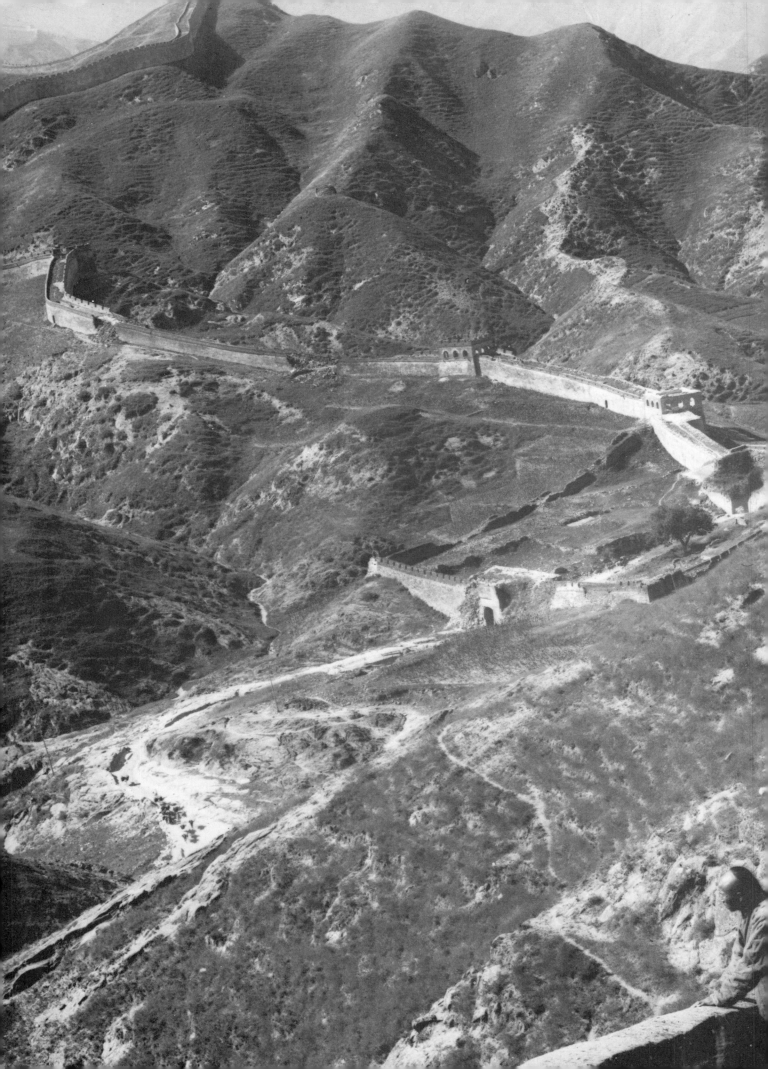

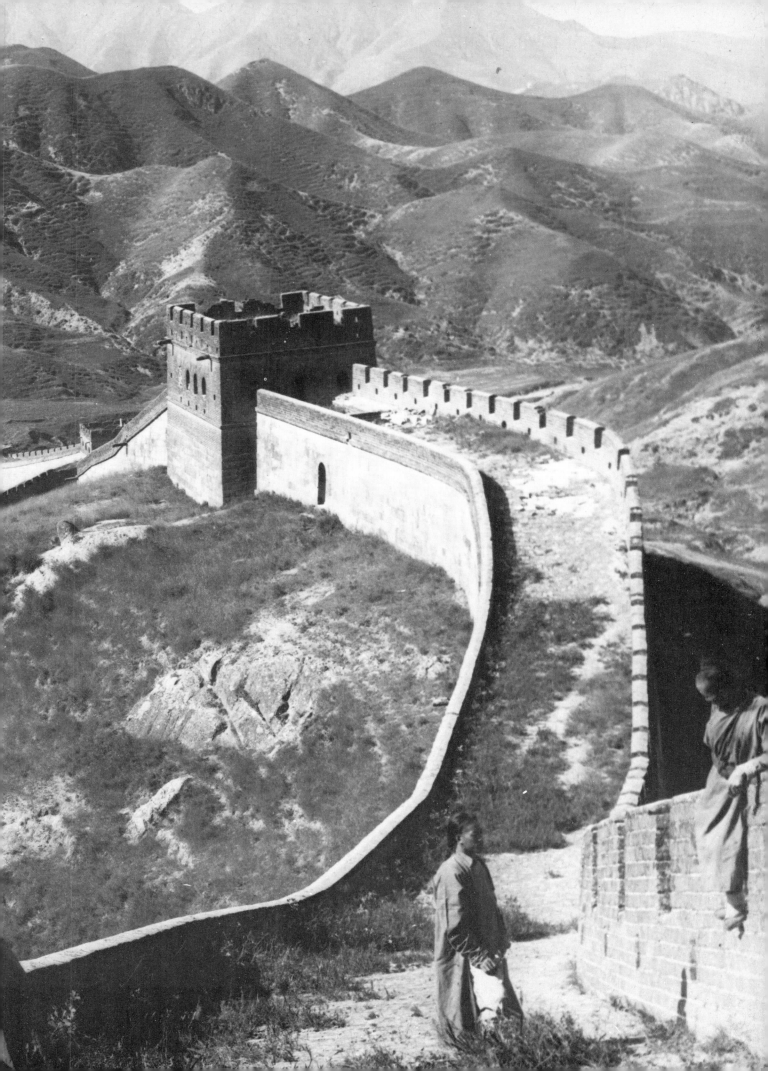

Previous pages: The Great Wall of China at the Nankow Pass. 'Before the Great Wall one has an indescribable feeling of awe, as the eye follows its interminable meanderings across the barren hills and sunbaked wastes of China'

Below and opposite: Stone figures guarding the tombs of the Ming Dynasty to the north of Peking. The tombs were approached by a *dromos* or avenue of huge stone figures representing warriors, ministers of state and animals. At Peking—there were other tombs at Nanking—thirty-two of the figures were ranged either side of the roadway for one mile. Their height varied from 10 to 15 ft

People and their Ways

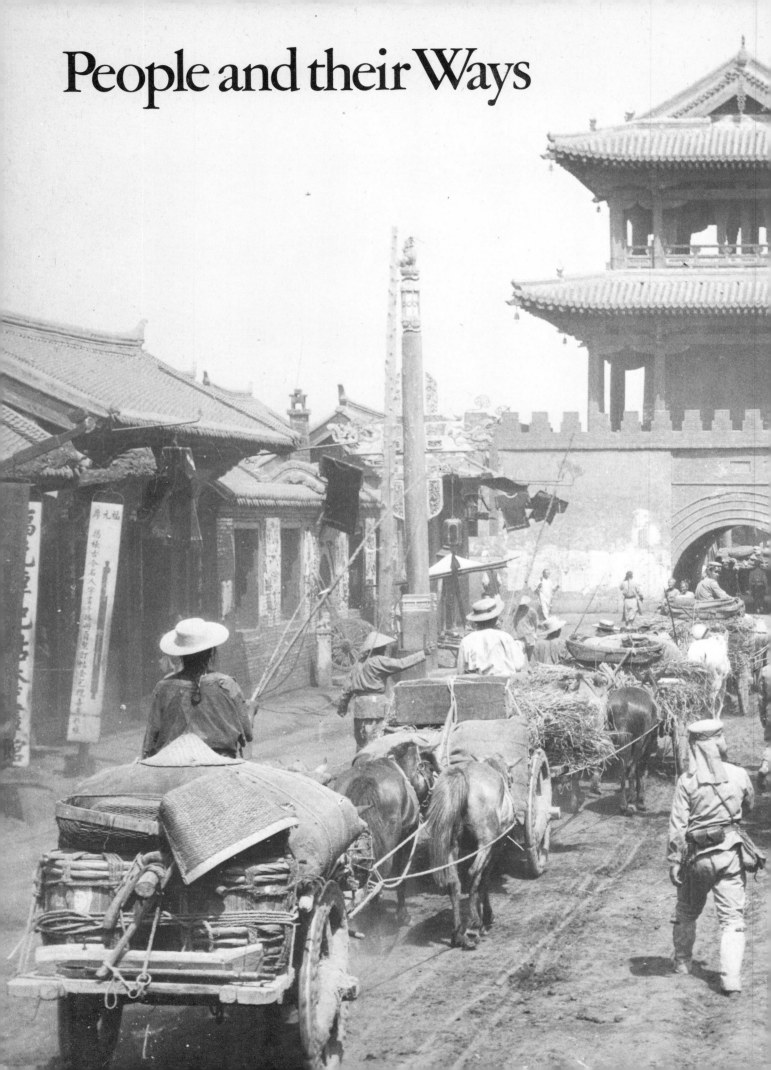

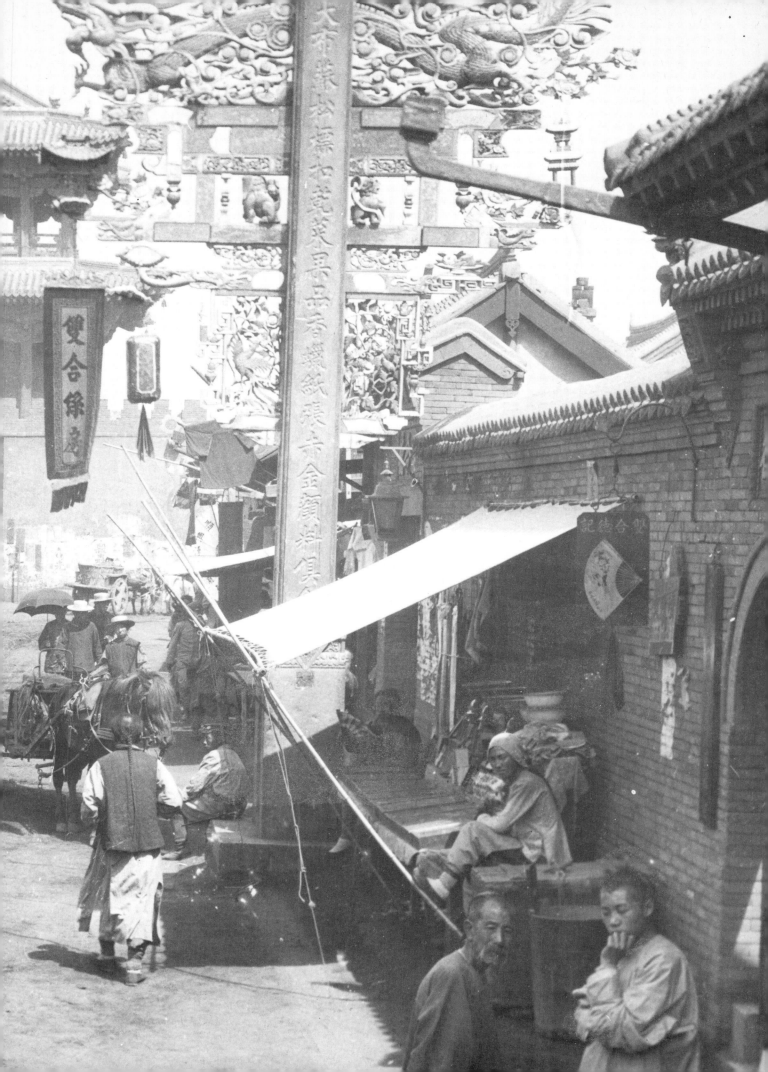

Previous pages: The Drum Tower, Mukden, Manchuria. Ponting travelled extensively in Korea and Manchuria before the outbreak of the Russo-Japanese War in 1904. Almost all this work was for picture agencies, and few negatives remain in his files

Below: The Burning Ghats, Benares. 'The bodies, swathed in thin cloth . . . were brought to the water's edge and bathed in the river . . . then the wood pyres were arranged and on each a corpse was placed. A relative applied the torch . . . I watched the sickening spectacle, fascinated with its horror and the desire to illustrate it all'

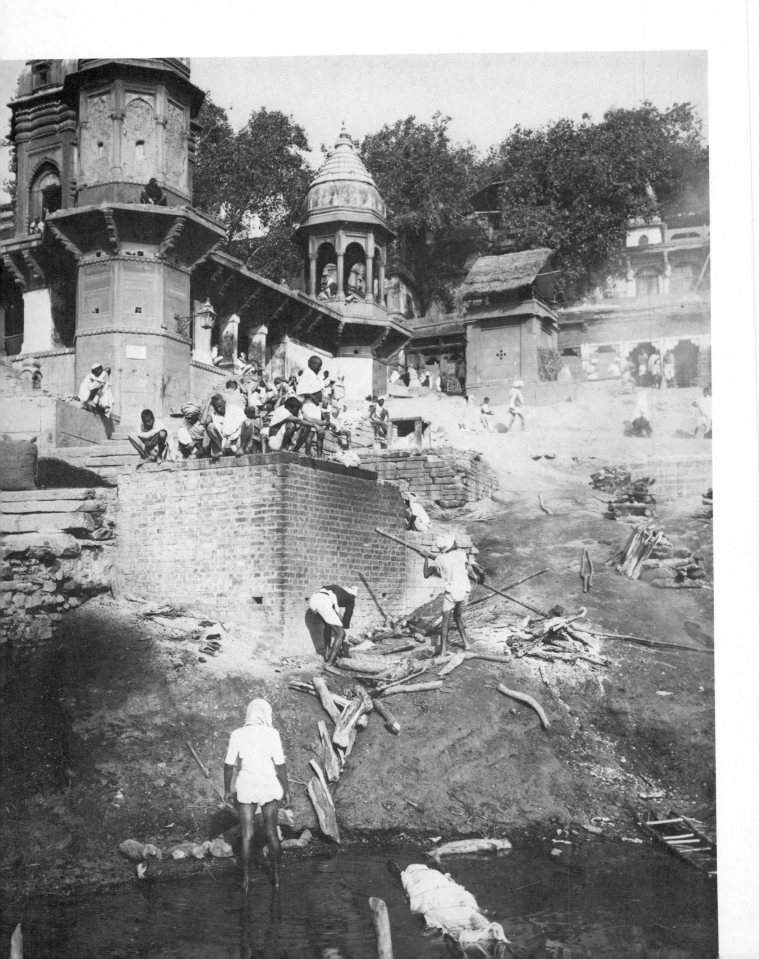

Hindus praying and bathing in the sacred Ganges at Benares

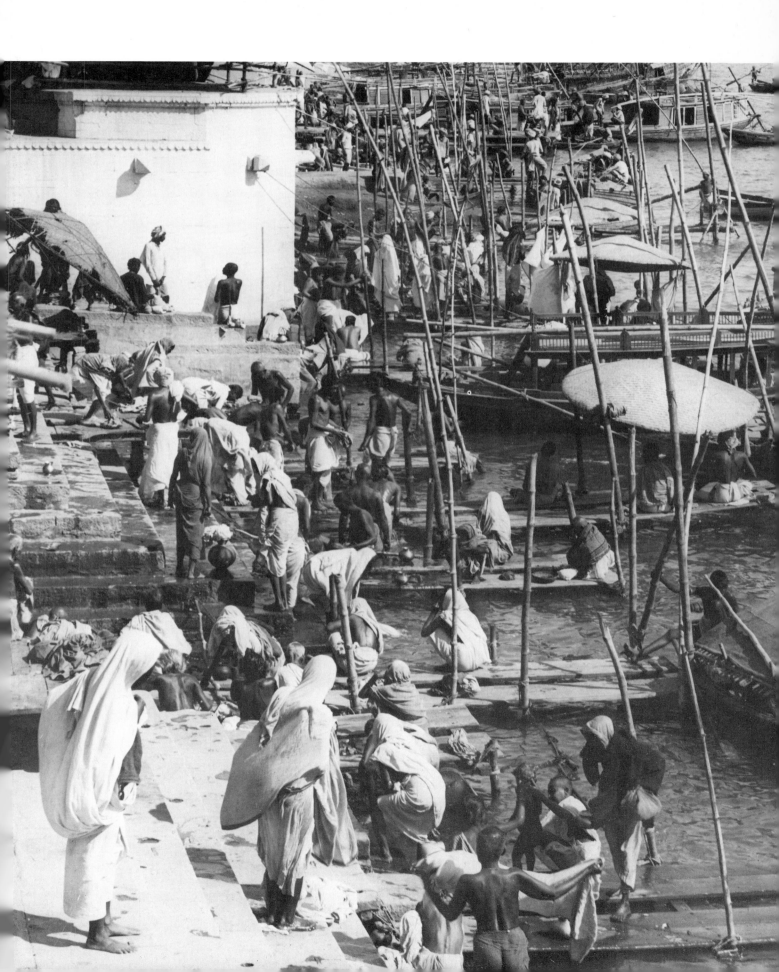

A seventy-foot leap into the Sacred Tank, Delhi. Sacred to the devout Hindu, to bathe in the water of such tanks or wells was to obtain deliverance from all penalties

Burmese girls rolling cigars. 'You creatures who live in a land where you are worshipped . . . by the men to whom you plainly show that you are perfectly aware of their adoration and that you think you quite deserve it too'

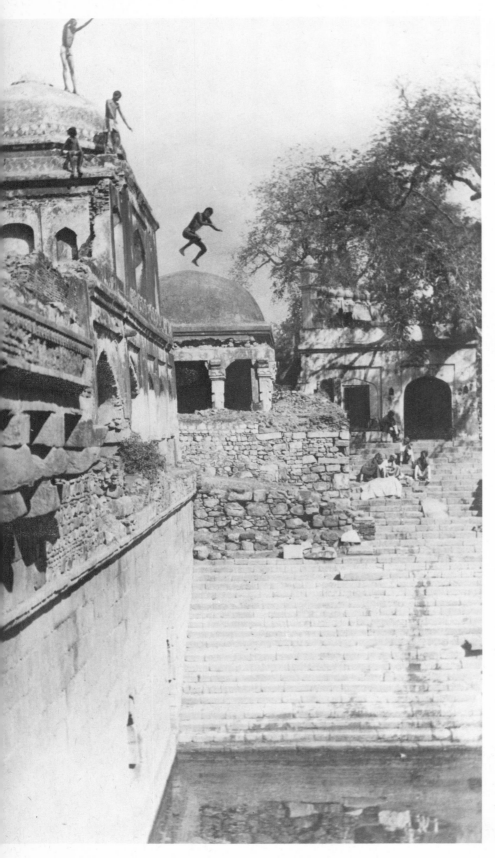

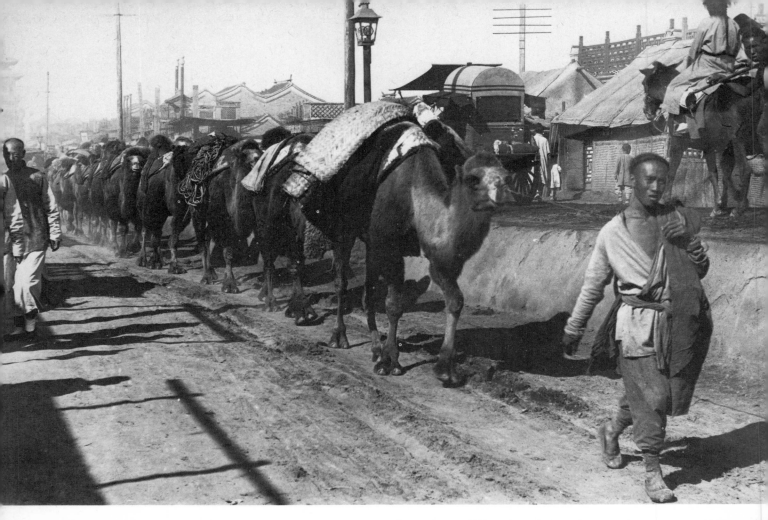

Above: Camel caravan passing through the streets of Peking

Above right: Chinese passengers eating aboard a Pacific Ocean steamer. Although famous mainly for carefully and lengthily composed landscapes and portraits, photographs like this showed that with a hand camera Herbert Ponting could capture the atmosphere of a fleeting moment

Right: Mongolians bringing young falcons to Peking. 'I learnt that the falcons would sell for about 15 shillings each. It is quite a common sight in the towns of North China to see the sport going on or the owners of the birds taking their pets out for an airing'

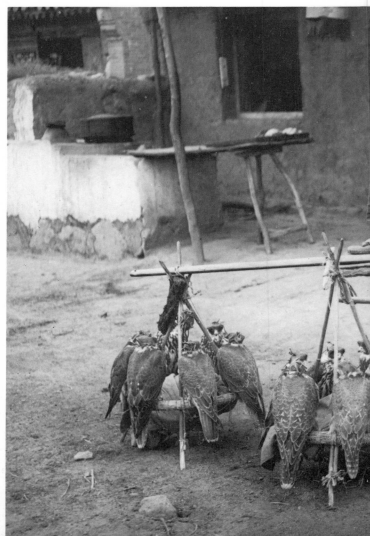

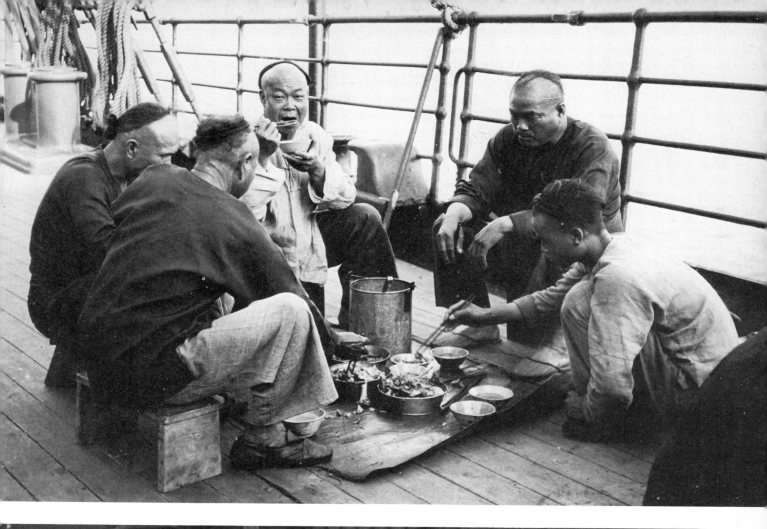

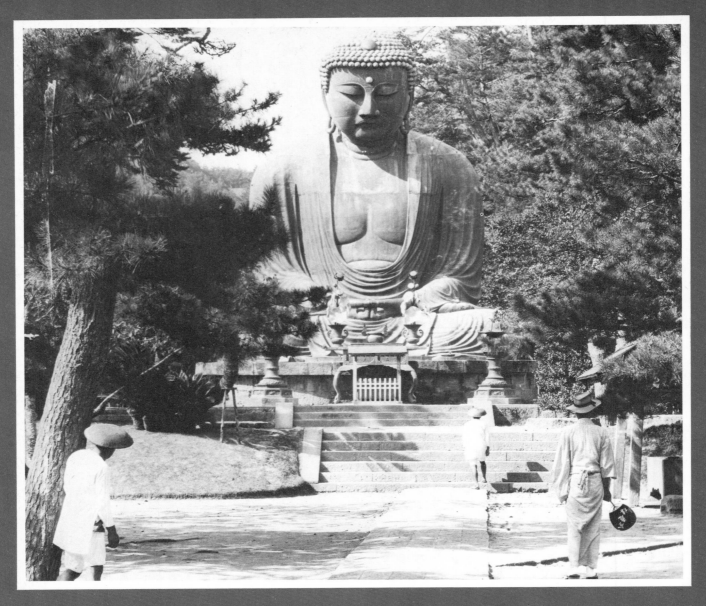

Above: The Daibutsu or Great Buddha at Kamakura 'seems to be vestured in the very cloak of peace, so subtly has the hand of man clothed it with serenity and spiritual calm'

Right: A public bath at Kanawa, Japan. 'The whole of this neighbourhood is so volcanic that hot springs abound almost everywhere . . . (the baths are) arranged as long troughs about fifteen inches deep and wide enough for a bather to lie in at full length. In these the bathers recline side by side . . .'

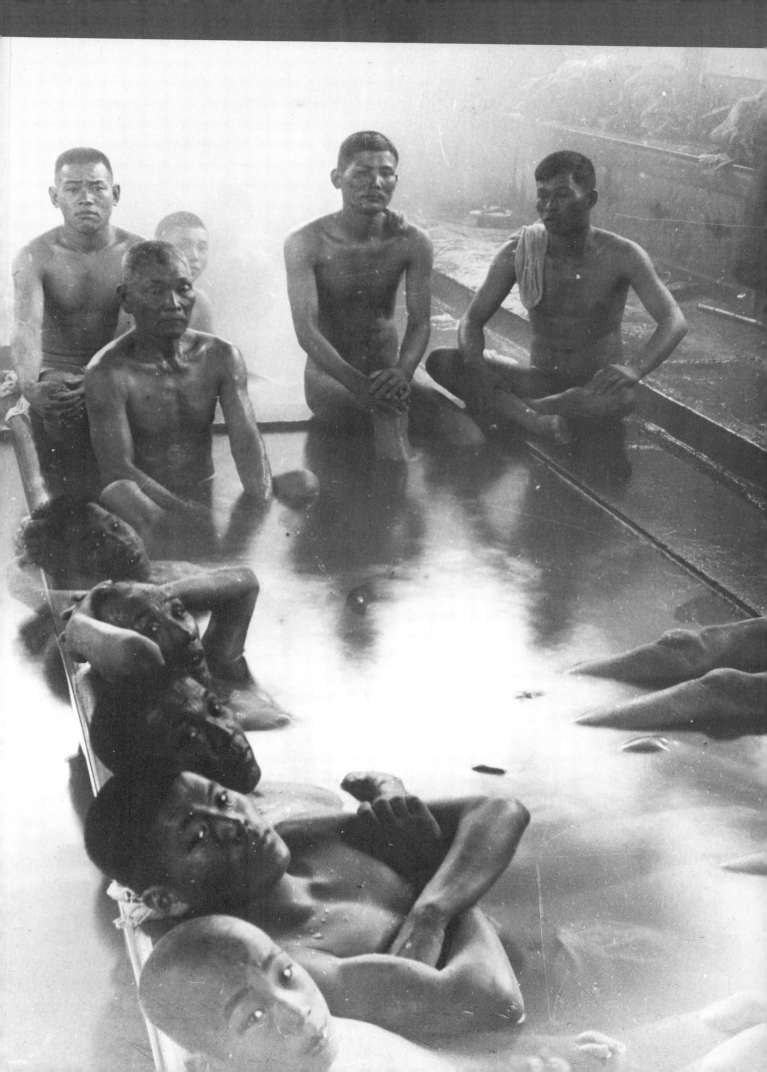

Writing a letter—another example of Ponting's talented photography by available light. The floor is covered by the traditional mats or *tatami*; a favourite dwarf tree is close by and the lady is sustained by tea

' "A delicate affair is beautiful hair" in most lands, but in Japan it is a very serious matter. The dressing of a lady's tresses may take an hour or two . . .'

A potter of Kyoto. 'In spring, summer, autumn and winter
I have seen him at his wheel, his raiment growing scantier
as the weather became warmer, until August found him
with nothing but a loin-cloth and a few medical plasters
to cover his rheumatic bones'

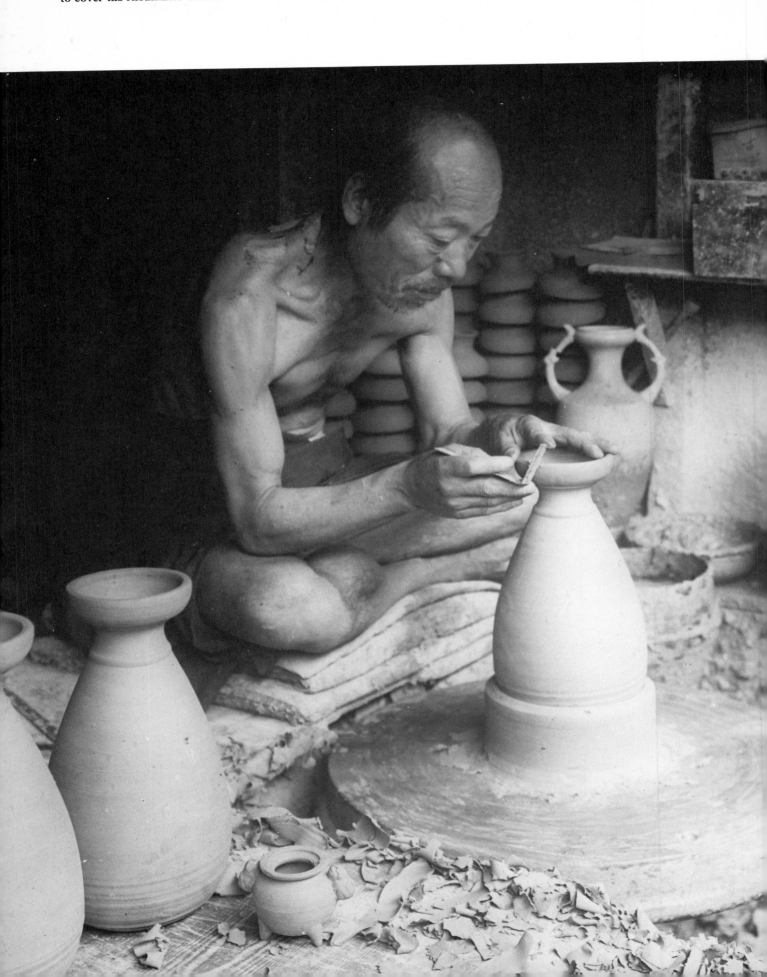

Below: The bronze sculptor, Kyoto. '. . . though many native crafts are being degraded by appealing to vulgar foreign taste, the product of the bronze workers—one of the most beautiful of all Japanese arts—excels that of the old-time days'

Bottom: The embroiderer, Kyoto. 'One may see . . . such marvellous embroideries of lions and tigers that only the closest inspection proves them to be the work of the needle and not the brush. The effect is only gained at the expense of a million or so of separate stitches'

A Buddhist priest and prayer wheel, Japan. Unlike
Tibet, no prayers are written on the Japanese wheels. In
life the 'perpetual succession of cause and effect resembles
the turning of a wheel. So the believer turns the
praying-wheel, which thus becomes a symbol of human
fate, with an entreaty to the compassionate god Jizo to let
the misfortune roll by . . .'

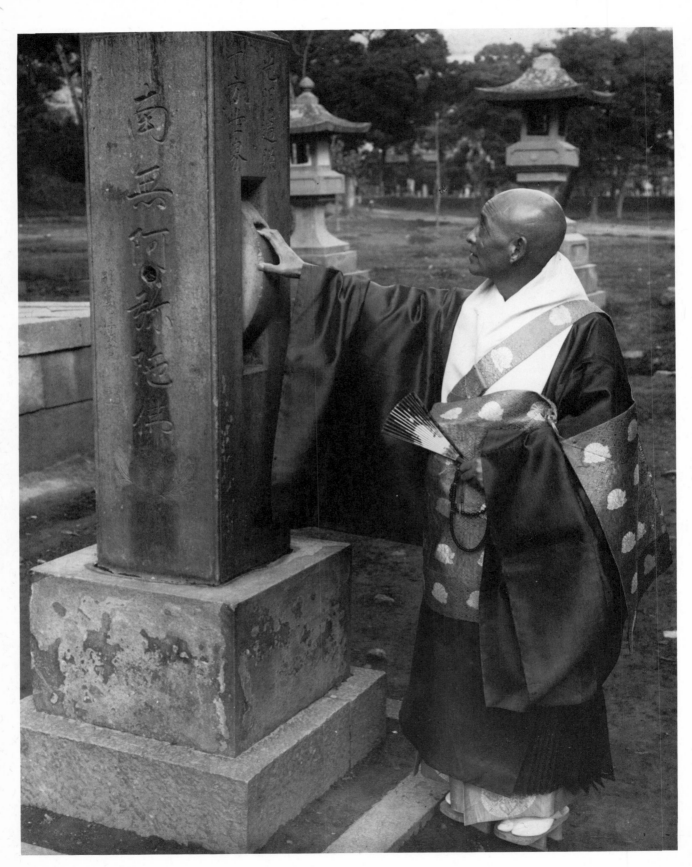

An amputation in a Japanese hospital. During the
Russo-Japanese War Ponting spent three weeks visiting
military hospitals in Hiroshima—an experience which
strengthened his great admiration for Japanese soldiers
and their womenfolk

Below: At work on the river. Right: Women diving for pearls at Shima, Japan. Bottom: Japanese fishing with cormorants

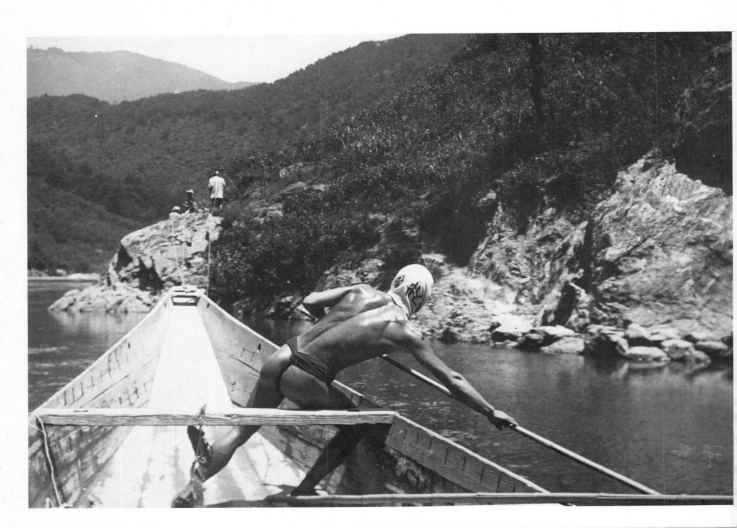

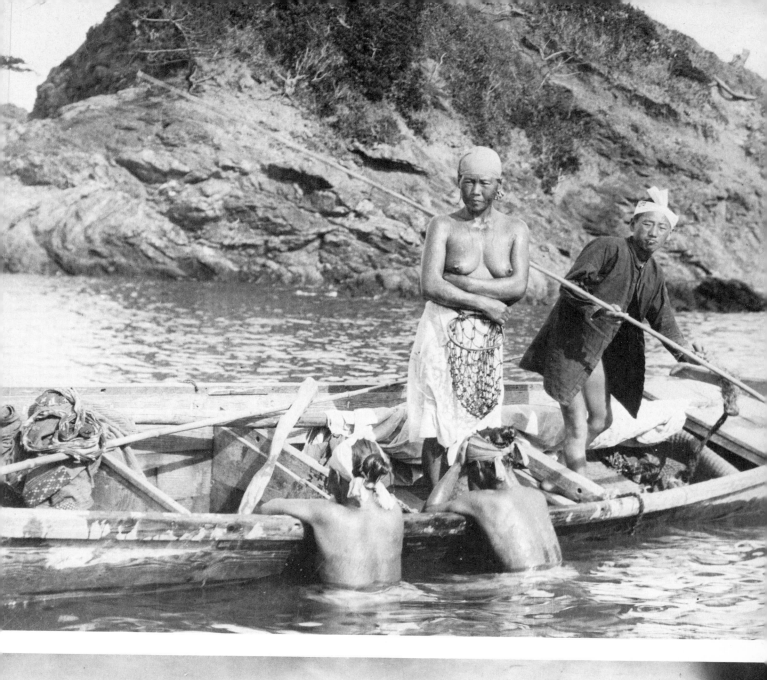
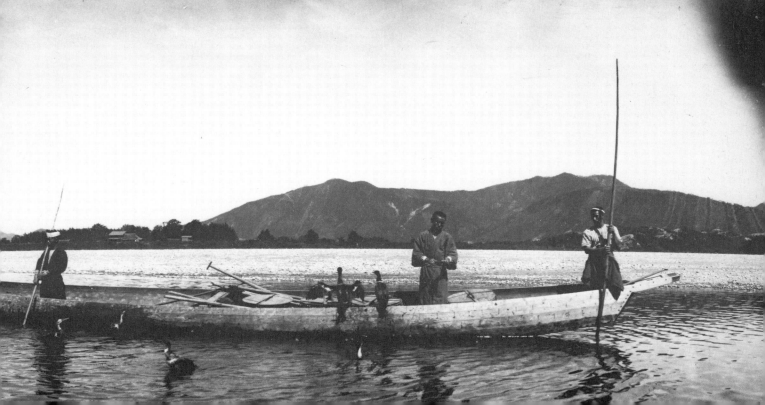

Andalusian girls, Seville. The confidence of their posture and obvious pride in displaying themselves were the noticeable features of this photograph

Mountaineers resting in the Bergli Hut, Jungfrau. Herbert
Ponting was a frequent visitor to Switzerland for
climbing expeditions until about 1913

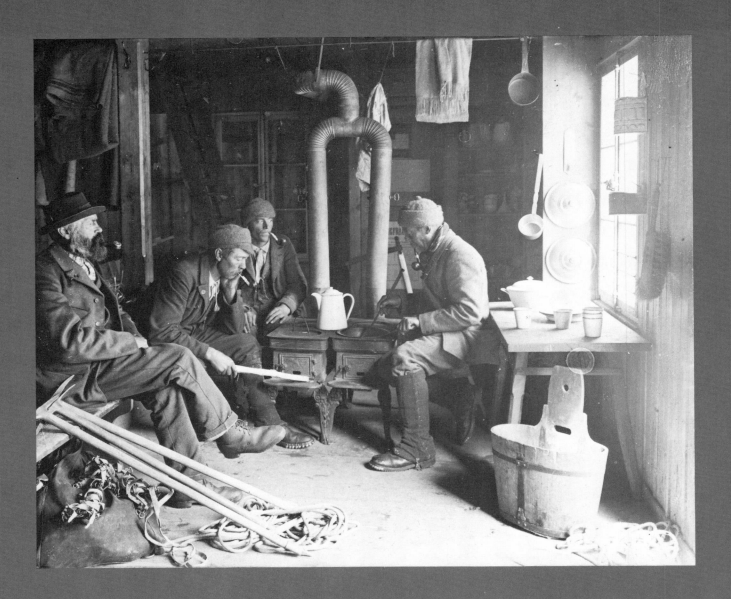

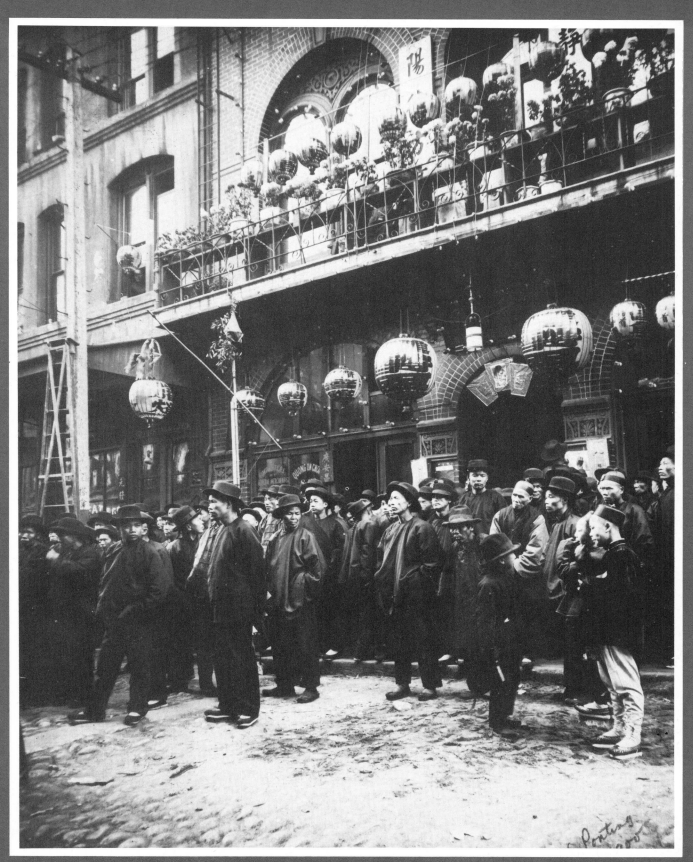

In Chinatown, San Francisco, 1900—a previously
unpublished picture. A contemporary of Ponting's, the
German Arnold Genthe, is chiefly remembered for his
photographic coverage of this part of old San Francisco
which was destroyed by the great fire of 1906

A fakir of Holy Benares, India

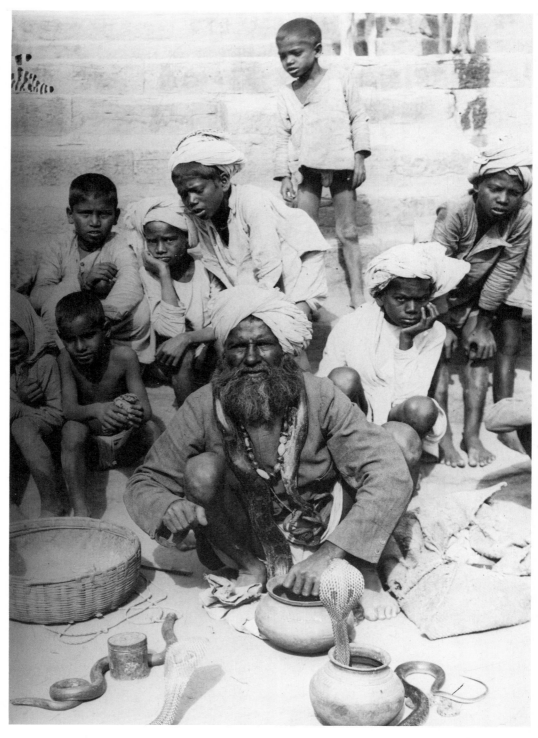

A snake charmer, Benares

Girl of Ceylon. A beautiful photograph and one of a very
few nude studies remaining in Ponting's negative files.
This may be the first time it has been published

A Burmese girl about 1905. 'She is quite content with her great cheroot, made of tobacco stems and leaf rolled into a package ten inches long and an inch and a quarter thick. She does not place it *between* her lips but only *to* them . . .'

Man with a pipe, Peking

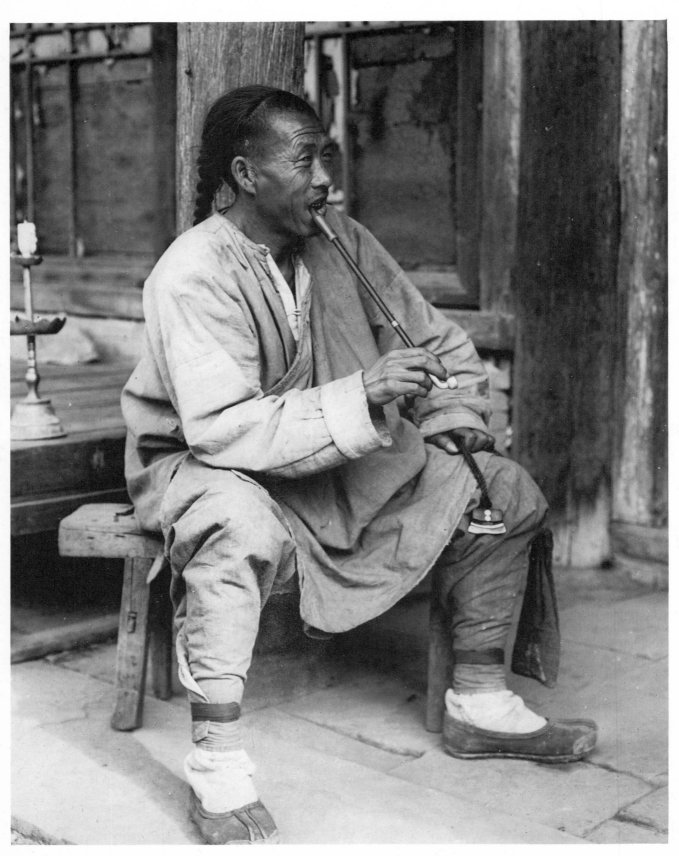

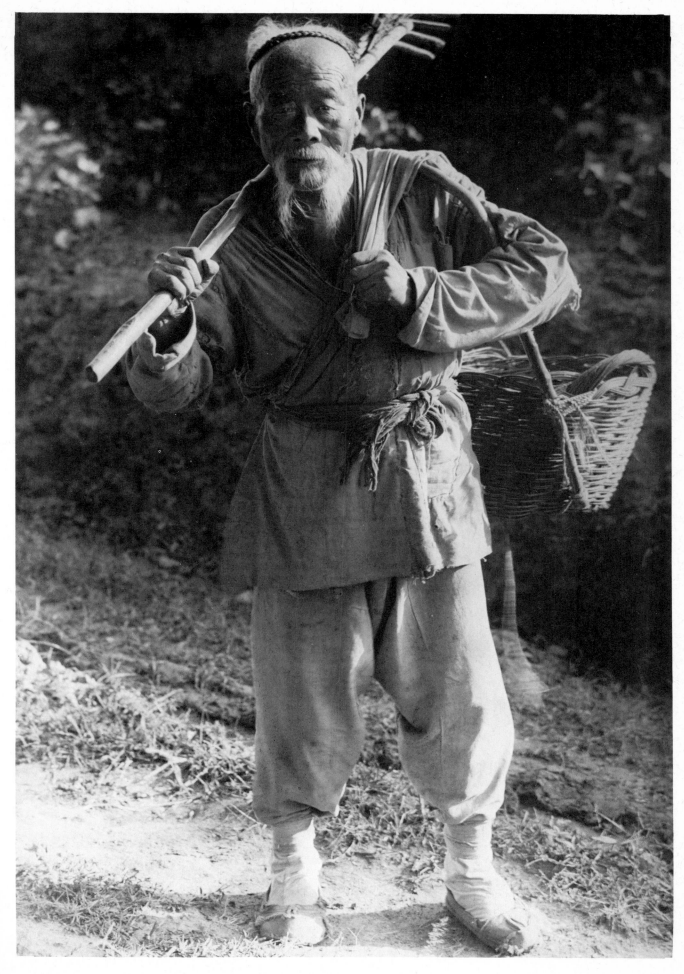

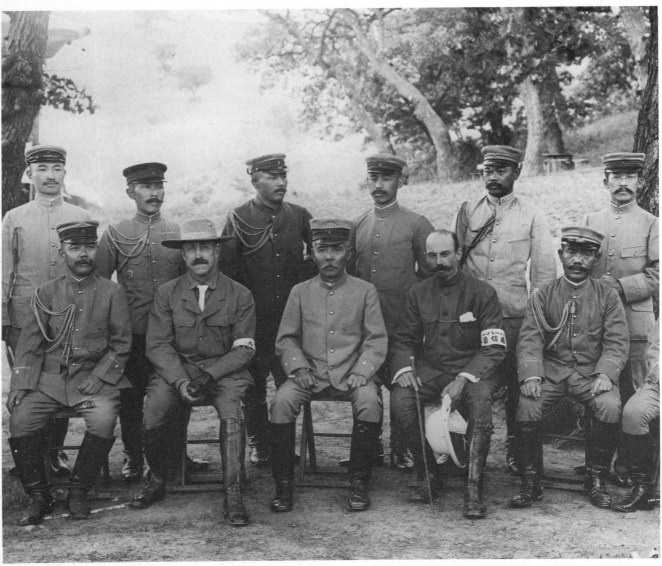

Left: An unidentified and delightful study of children taken in China or perhaps Manchuria, probably during a break at a railway station

Below left: Ponting (second from right, front row) with General Kuroki – commander of the Japanese First Army in Manchuria during the Russo-Japanese War – and his staff. The other correspondent may have been Edwin Emerson, a war reporter who had much admiration for Ponting's work

Below: A native of Java. Without using the usual techniques of photographic portraiture, e.g. selective focus, Ponting could frequently establish the essence of his subjects. Here, self-confidence, even arrogance, are evident

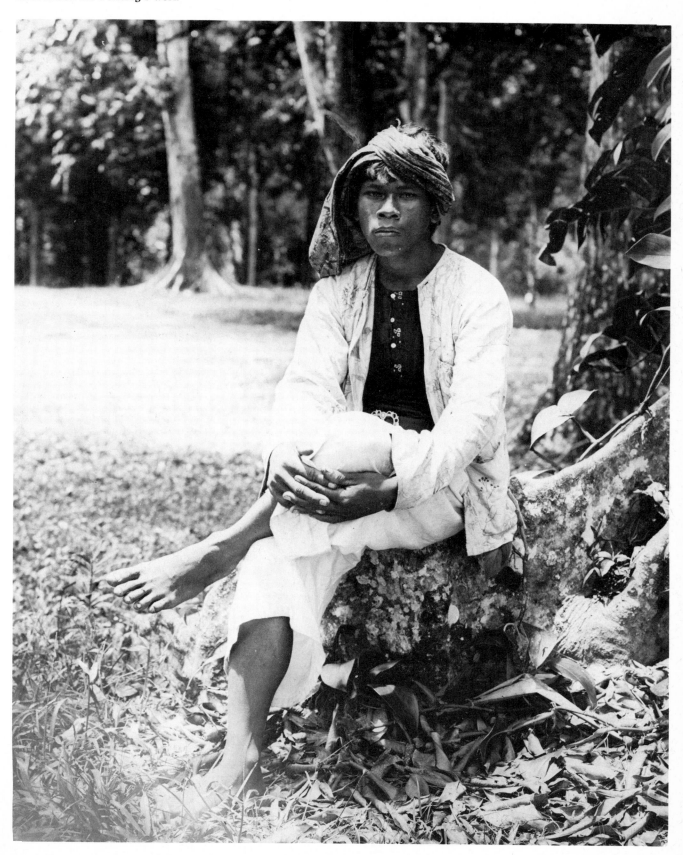

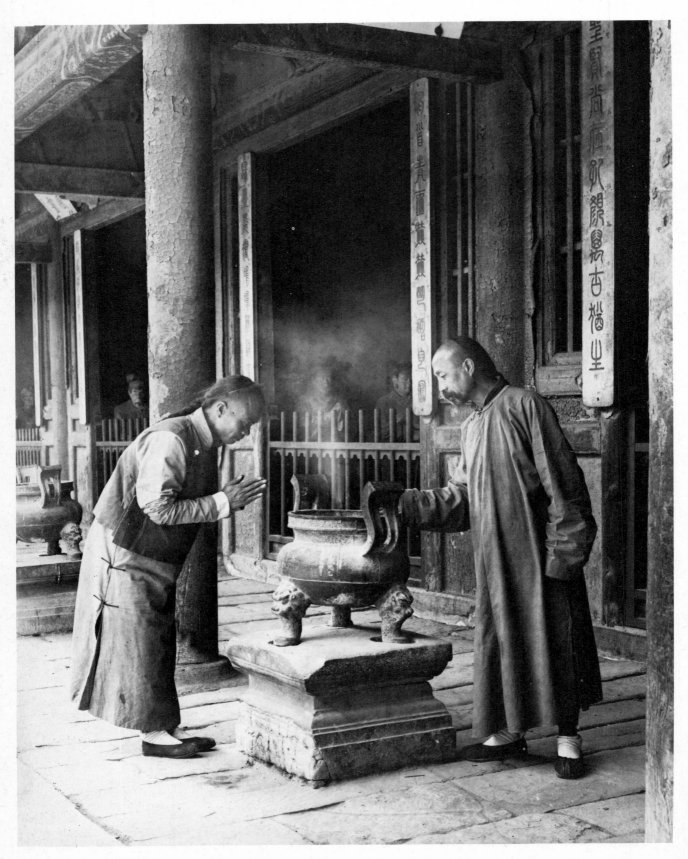

'The scenery of Nikko (where the greatest of Japan's old-time rulers are buried) . . . is unrivalled in all Japan, and the air is soft and sweetly scented, and stimulating as rare old wine.' An old man rests in an avenue of Buddhas carved from stone

Feeding deer in a park at Nara, an ancient capital of
Japan. 'As soon as rikisha wheels are heard, deer come
bounding out of the bracken . . . Long immunity from
molestation has made the gentle creatures very friendly
. . . an exceedingly charming and purely Japanese feature
of this avenue is the great number of old stone lanterns
among the trees'

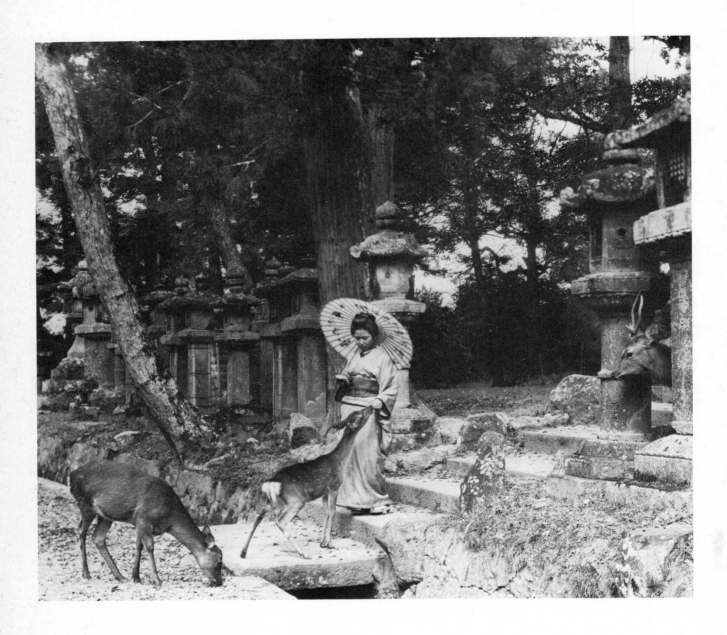

Under the purple wistarias—the photograph which, hand-coloured, formed the frontispiece of *In Lotus-Land Japan*. 'Each May is heralded by the most graceful and delicate of all Japanese flowers, and with the blossoming of the wistarias one feels that summer is indeed at hand'

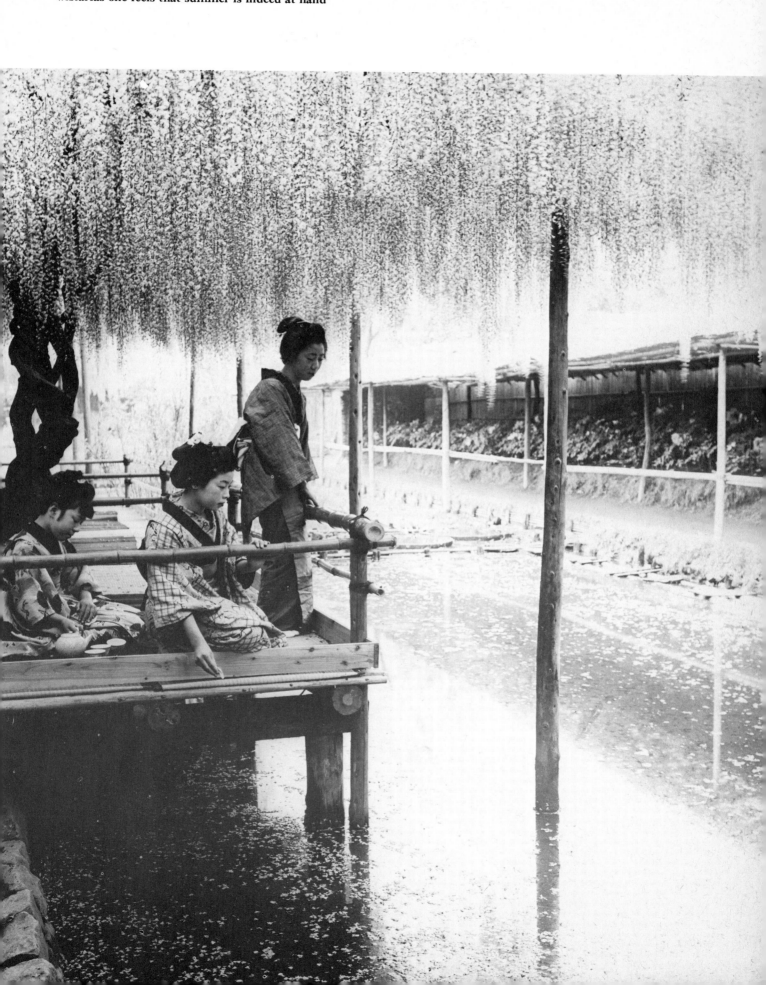

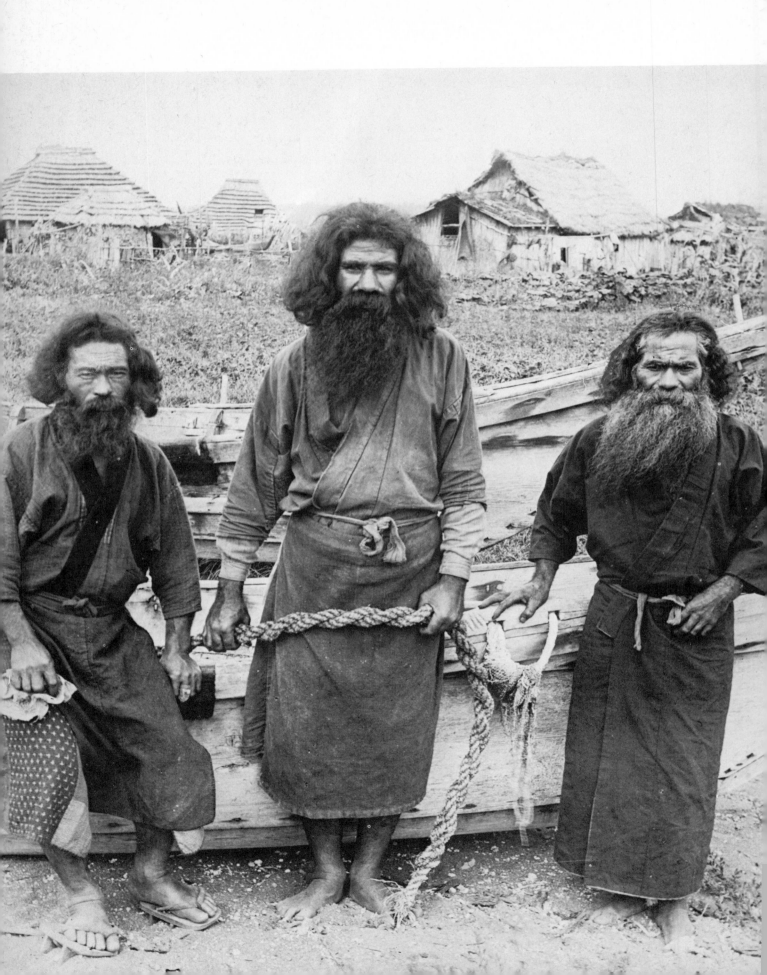

Happu Konno (centre)—one of the most famous bear hunters in Yezo—and two other Ainu fishermen. 'The killing of a bear is looked upon by the Ainu as the greatest of all possible feats'

Ainu man and women. The prevalent custom amongst
the women was the tattooing of moustaches on the upper
lip. The Ainu were the aborigines of Japan and Ponting
was critical of the manner in which they 'are held in
utter contempt by the clever, enlightened Japanese and
are left to work out their own salvation'

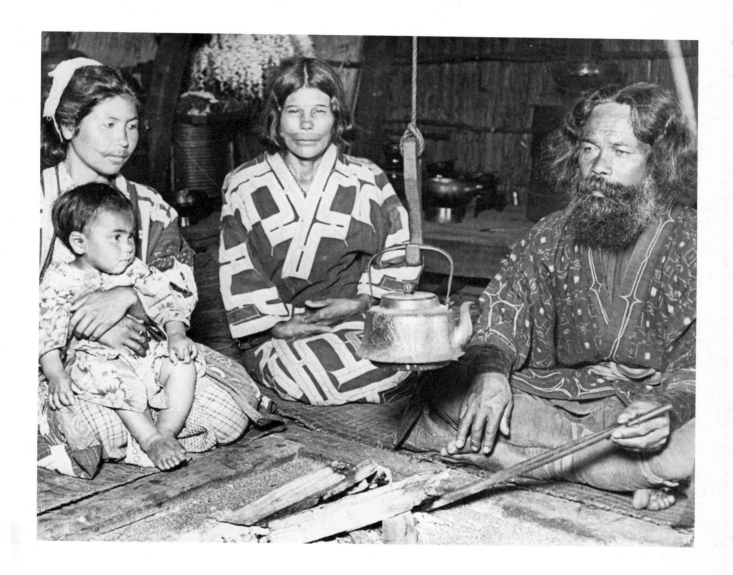

Fisherman's children, Mito Bay. 'Our old boatman's grand-daughter—a little brown eyed lass of nine—came down to see us off, with her baby brother on her back. They . . . were delighted when I made a hasty photograph . . . and told them I would show the picture to some of my small friends in England and America'

Right: A Shinto priest of Kunozan

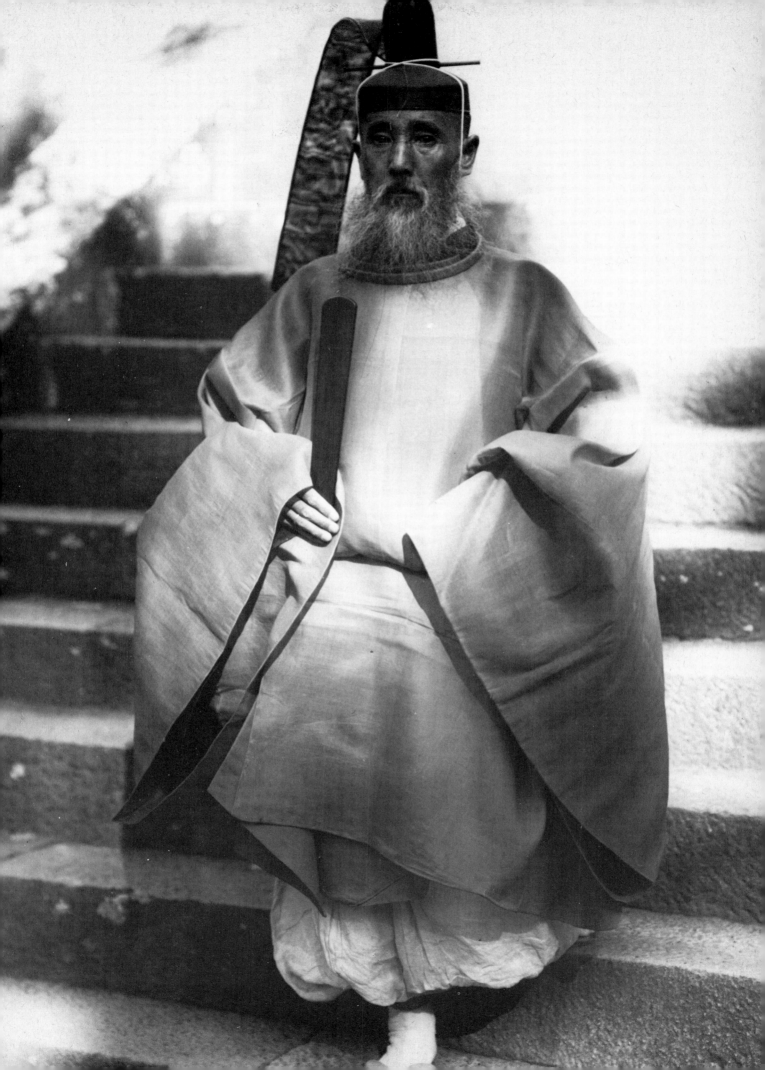

Left: Prince Hirobumi Ito, Princess Ito, their son Hirokuni and two grandsons photographed at their country home. Prince Ito—with whom Ponting had a number of lengthy meetings—was one of Japan's leading politicians at the turn of the century and, as chief of the elder statesmen, was private councillor to the Emperor. After the Russo-Japanese War he was given responsibility for Korea and was assassinated by a Korean at the end of 1909

Below, far left: Ponting called this picture of a geisha 'By the *karakami*'—karakami being the sliding doors which divide one room from another in Japanese households. The *shoji* or sliding screens covered with rice paper admitted soft, diffused light of which Ponting took the maximum advantage in his photographs

Below left: Mr Y. Namikawa of Kyoto, a brilliant artist-craftsman of enamelled ware or 'cloisonné'

Below: A Manchurian family, Peking

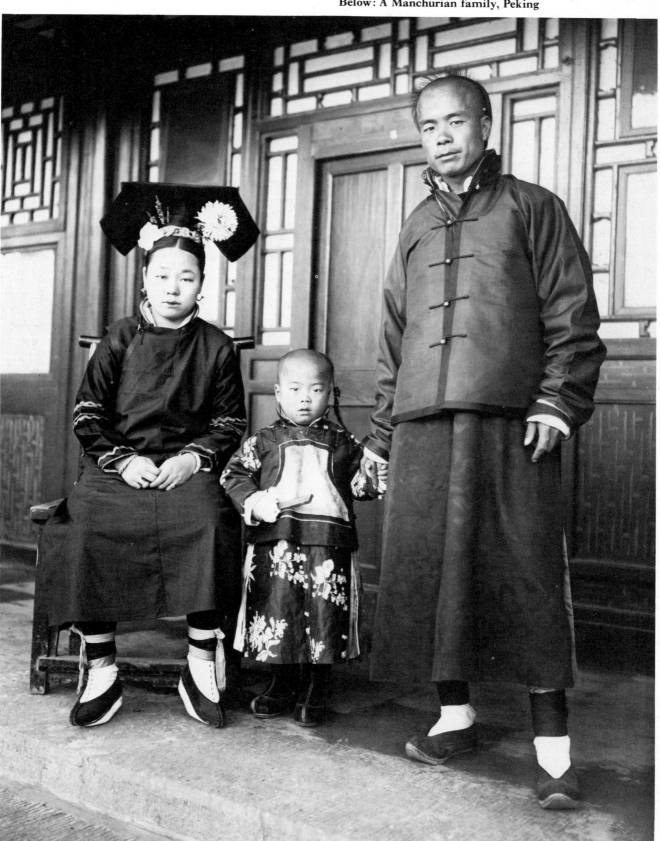

125

A chronicle of everyday Antarctic life. Petty Officer
Patrick Keohane and the Russian groom Anton
Omelchenko were the subject of this hair-cutting study

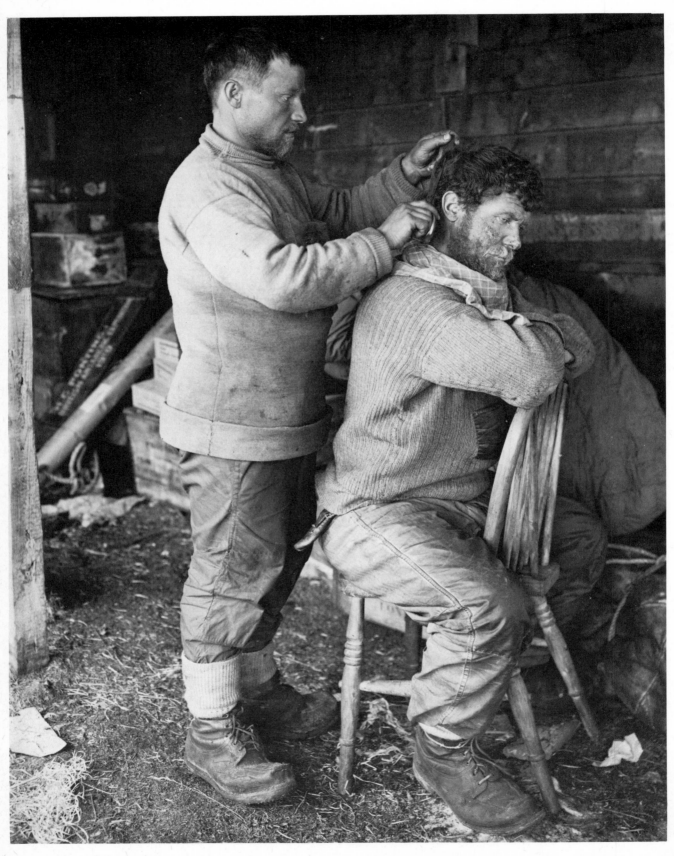

Below left: Cecil Meares was a member of one of the support parties which ferried supplies for the polar party to the foot of the Beardmore Glacier. Ponting photographed him on 5 January 1912 immediately on his return from a round journey of some 800 miles. Exposure and exhaustion are etched in every line of the face

Below right: Edward Wilson, chief of the scientific staff. He was held in deep affection by all members of the expedition—and none more so than by Ponting. Dr Wilson was a talented artist and the two of them planned a joint exhibition at the end of the expedition. From London on 27 October 1912—when Wilson and the other members of the polar party were already dead—Ponting unknowingly wrote to him: 'If any incentive were needed to make my thoughts fly to you, these weary months that I have been struggling with my results in London, it has been supplied in the number of times I have seen your genial, smiling countenance on the screen'

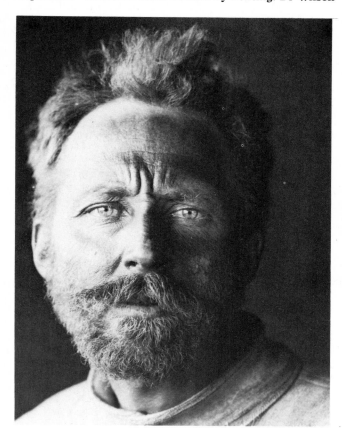
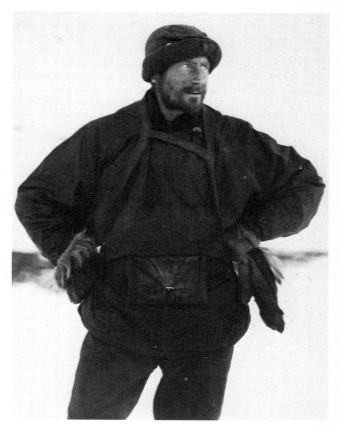

Index

Illustrations are indexed by their captions; an asterisk* indicates that the photograph described is wholly on another page.